David Bellamy's
Coastal Landscapes

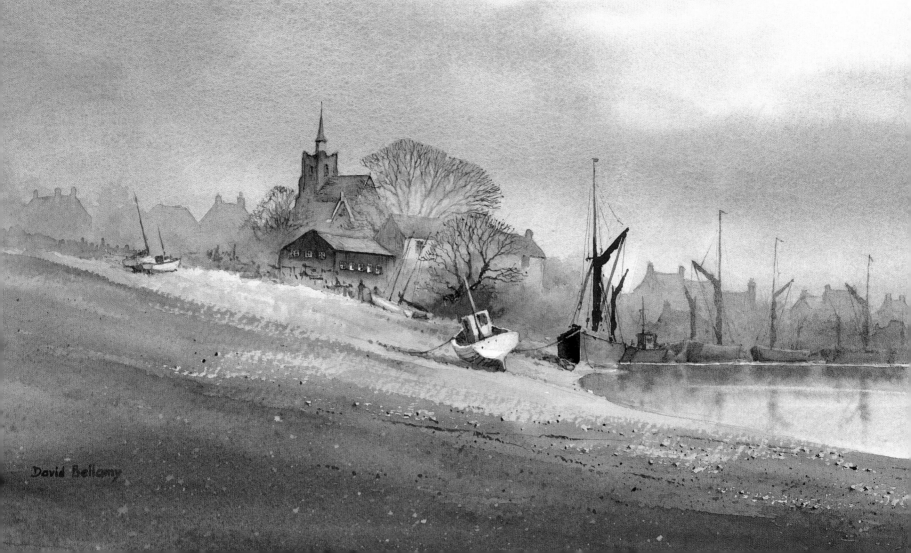

David Bellamy

David Bellamy's
Coastal Landscapes

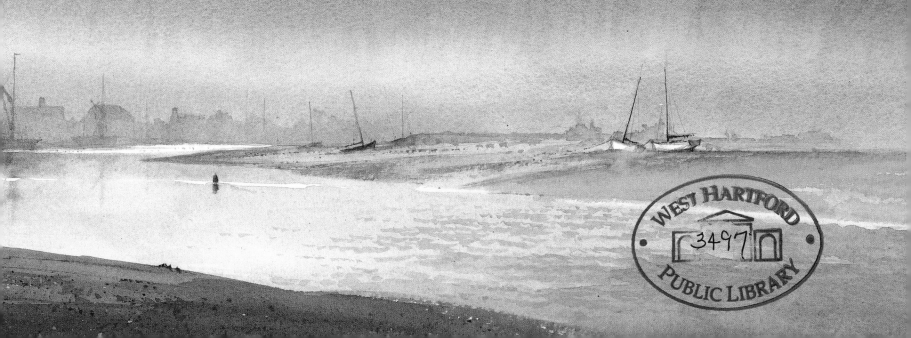

To my brother Malcolm who loves the sea so much he frequently jumps into it on the Tenby Boxing Day Charity Swim.

Acknowledgements

I would like to thank Cathy Gosling and Tess Szymanis at HarperCollins, Geraldine Christy the editor, Anita Ruddell the designer, Eric Lees and George Taylor for the photography, Jenny Keal for checking the manuscript and taking the photographs on pages 6 and 8, and Catherine Bellamy for the photograph on page 62.

Videos on watercolour painting by David Bellamy can be obtained from APV Films, 6 Alexandra Square, Chipping Norton, Oxfordshire OX7 5HL (tel. 01608 641798)

David Bellamy's website address is www.Davidbellamy.co.uk

First published in 2002 by
HarperCollins*Publishers*
77-85 Fulham Palace Road
Hammersmith
London W6 8JB

The Collins website address is:
www.collins.co.uk

Collins is a registered trademark of HarperCollins Publishers Limited.

03 05 07 08 06 04
2 4 6 8 10 9 7 5 3

© David Bellamy, 2002

David Bellamy asserts the moral right to be identified as the author of this work.

A catalogue record for this book is available from the British Library

ISBN 0 00 712176 8

Editor: Geraldine Christy
Designer: Anita Ruddell
Photography: George Taylor and Eric Lees

Colour origination by Colourscan, Singapore
Printed and bound by Printing Express Ltd, Hong Kong

Q
751.4224
BELLAMY

F

Page 1:
Trwyn Aber Rhigian, Pembrokeshire
watercolour
15 x 30 cm (6 x 12 in)

Page 2:
Hazy Evening, Maldon
watercolour
33 x 61 cm (13 x 24 in)

Opposite:
Polperro, Cornwall
watercolour
23 x 16.5 cm (9 x 6½ in)

CONTENTS

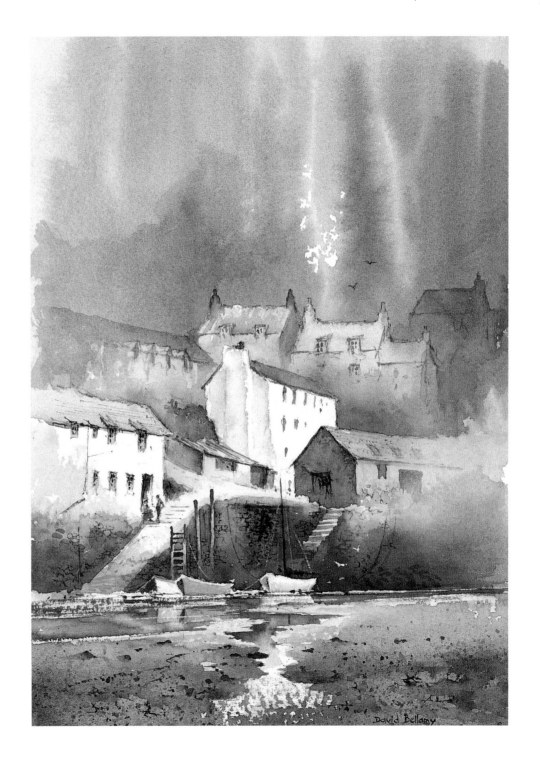

David Bellamy

1 INTRODUCTION

There is a marvellous sense of freedom by the sea, wandering along the shoreline, exploring cliff-girt coves or painting the delights of a harbour; and life seems more relaxed. To paint and sketch in this environment is not only rewarding artistically, but extremely therapeutic as well. In summer the artist can get away from those overwhelming greens of the landscape. Even when the weather is misbehaving you can still find much to do, depending on your individual approach to alfresco working. Indeed, when the sea is at its wildest I revel in the movement and power of the storm even if it is almost impossible to keep the sketchbook steady.

Set against these joys of being by the sea, though, hover those artistic plagues that make inland painting appear almost carefree by

▽ **'Sea Star' in South Canada Dock, Liverpool**
pencil sketch

comparison: a constantly moving sea, overwhelming masses of rock and fiendishly shaped boats, with other odd difficulties to follow. These delights have been known to send people home muttering about throwing away their art materials, yet the very same delights transport others into ecstasy. The aim of this book is not only to help you to portray these devilish subjects, but to get you revelling in them, and enjoying your painting.

WORKING IN VARIOUS MEDIUMS

While watercolour has been my main medium for many years, I have always felt it important to paint in pastels and oils now and then. Indeed, I gave up

◁ **The author at work**

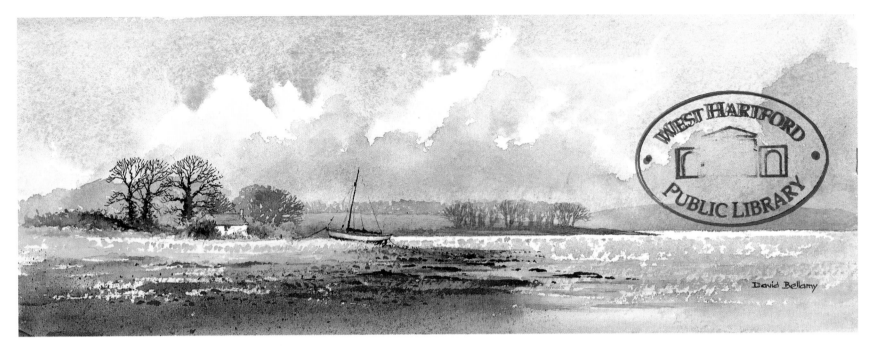

⬑ Llangwm, Pembrokeshire
watercolour
10 x 30 cm (4 x 12 in)

watercolour painting at an early stage as I found the medium difficult to handle, and felt that oil painting was more my scene. Only by going into the mountains and working up watercolour sketches in the most bizarre circumstances did I finally get to grips with watercolour, out of necessity. Each medium has its advantages and disadvantages, and those who simply stick to one are really missing out, because you learn so much from each one.

Watercolour is a difficult medium for beginners. Being transparent, watercolours have to be worked from light to dark, so you cannot paint a light tree trunk over a dark background, for instance; washes are hard to control; and mistakes not easy to rectify, often impossible. Nevertheless, watercolour is wonderfully expressive once you learn how to handle it.

Pastel painting is far too messy for some. Many also find it difficult to render detail in pastel and

become frustrated with their efforts. These complications can be overcome and the richness of the medium exploited to produce paintings ranging from quick impressions to a grand *tour de force*. It is amazing what you can achieve with pastels in very little time, so it is perhaps an ideal medium for those who have limited hours to spare at the drawing board.

Sadly, oil painting has become rather neglected in recent years, which is a great shame as the medium can be used to produce some powerful works. A great advantage of the medium is that it can be overworked and you can completely change a painting in mood, colour, tone or composition in just about any manner. This versatility makes it an excellent beginner's medium, and you can stop and start whenever you wish. Admittedly more cleaning up is required than with watercolours, but the problems of strong-smelling oils and diluents can be avoided.

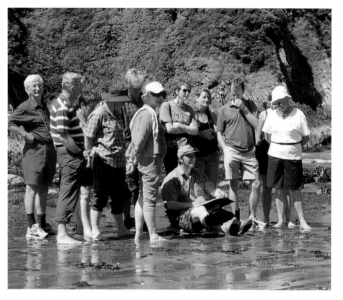

◊ **A painting demonstration**

The author carrying out a watercolour demonstration on wet sand for a course.

In no way, however, would I encourage you to sally forth and paint in every medium under the sun. It is confusing to jump from one to the other in rapid succession, so stick with what you know for now or, if you are just starting, choose a medium that seems to feel right to you. Work through the book in that medium, but do read those chapters and passages relating to the other mediums, for you will learn much more that way. Have a go at all the exercises, but work in your chosen medium. Once you have gone through the book and have some experience think about trying one of the other mediums. You may wish to postpone this until you are more accomplished. When you do make the effort, however, stick with the new medium for some time. Do not be easily discouraged by poor results, because painting is a case of trial and error. Perseverance is vital.

Many potential artists are put off because they feel they cannot draw, or have been told in the past to 'take up knitting!' Amazingly, this cruel put-down is common. We can all draw to a degree, and it is a question of application. In fact, it is one of the first things covered in the book. Do not worry if you cannot draw, as you can get round these problems. Drawing and sketching are not only the main highway to artistic success; they are highly therapeutic and enjoyable pursuits.

TACKLING THE EXERCISES

At the end of each chapter from Chapter 4 onwards you will find exercises in which you are invited to carry out a painting based on a photograph of a scene, as in some of my previous books. My versions of the subjects can be found in Chapter 15, but you will benefit by not examining my efforts until you have done your own painting in whatever medium appeals to you. My own paintings are not meant to be 'model answers' or the best way of dealing with the subject – they are simply one way. Everyone will approach the exercises slightly differently.

Also included in this book are suggested sketching exercises. Unlike the painting exercises, there are no specific set subjects as the intention is to give you ideas to work on in stages at your own pace. Although the simpler exercises are found in earlier chapters, there is no need to stick rigidly to the order given, as it often depends more on which part of the coast you are visiting or live in, and what opportunities you encounter. If you follow all the sketching exercises, carrying out the suggested work, it will undoubtedly improve your drawing, sketching and observation.

VISITING EXHIBITIONS

Apart from the exercises, constant painting and sketching will fast-forward your work. Visit

exhibitions by first-class artists whose work you admire, especially the Old Masters. While works by maritime painters of the calibre of Adriaen Van de Velde (1636–72), J. M. W. Turner (1775–1851) and Richard Bonington (1802–28) are well known, the paintings of landscape artists who occasionally painted the coastline will also benefit examination. These include John Sell Cotman (1782–1842), David Cox (1783–1859) and John Constable (1776–1837) and a whole host of lesser-known yet extremely gifted artists, such as William Callow (1812–1908) and Anthony Vandyke Copley Fielding (1787–1855) and many others who did much painting by the sea.

Paradoxically, while watercolour painting is so popular with leisure painters, and a medium in which Britain in particular has long traditions, the vast majority of watercolours by the Old Masters cannot be seen on exhibition. Tragically, these great treasures lie mainly unseen in vaults. On a visit to the National Maritime Museum in Greenwich I had hoped to view some of the museum's vast stock of watercolours. Less than a handful were on show and this is commonly the case in many public galleries and museums. These collections could at least be exhibited on a temporary basis and not imprisoned forever in some temperature-controlled hi-tech dungeon. When this situation is set alongside the fact that currently art schools appear to 'rubbish' such traditional basics as life drawing and applying paint to a two-dimensional surface, it is hard to avoid the thought that the Art Establishment is conspiring to kill off traditional art in favour of street-led gimmickry. It is surely up to each of us to constantly complain about this sad state of affairs so that eventually we may see common sense restored.

The range of subjects covered in this book is wide and includes ports, harbours and the sea, as well as landscapes inland from the coast. Find out what coastal subjects excite you most and work on them, simply at first, then gradually painting more complicated scenes as you develop your skills. Most of all, enjoy your painting; if you are too tense it will show in your work.

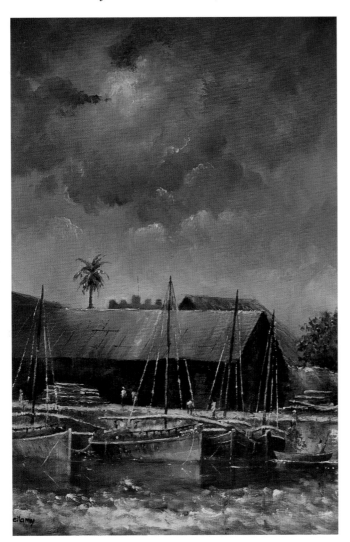

◊ **Dhow Harbour, Zanzibar**
oil on canvas panel
41 x 30 cm (16 x 12 in)

The sky included both French Ultramarine and Coeruleum with Naples Yellow and Titanium White around the lighter area. The darker areas were mainly worked in using French Ultramarine and Raw Umber mixes, sometimes adding Yellow Ochre or Scarlet Lake. After leaving the painting for a day or two, I resumed with some Yellow Ochre and Titanium White over the hulls, with French Ultramarine and Raw Umber for the darker parts, brought down into the water. The rigging was painted with Naples Yellow plus white, using a fine brush.

2 MAKING A START

If you are a beginner, taking up painting can seem daunting. This chapter is designed to build up your confidence, get you started and to prepare you for tackling the landscape. Painting is not as easy as it is sometimes made out to be, and you cannot expect to create masterpieces overnight. However, this constant struggle is part of the charm of painting and with practice you will see your work gradually improve until real progress is made.

To be able to draw is half the battle, for, as Ingres said, 'Drawing is the true test of art'. Accuracy is vital where linear perspective or complicated boats are to be rendered. We spend years learning and practising our drawing, then once competent we spend years trying to lose that precision to inject character into a feature and break up those rigid lines, but it is essential to learn the basics before introducing a less 'tight' approach. Not everyone can draw well, so if this is the case the first thing you need to address is to improve your drawing. Those of you in this position should take heart from the fact that there are subjects that you can paint that do not demand first-rate drawing skills, but more of that later.

DRAWING MATERIALS

Happily you do not need much to begin drawing. Indeed, you could if desperate start with the back of an envelope and an old ballpoint pen – I have been forced to resort to this method more than once when finding myself without any drawing equipment and confronted by a stunning subject. The results of one such occasion even appeared in a previous book!

Most important are a few pencils ranging from HB to 4B – give them all a few squiggles and see how they vary – and cartridge paper in sheet or pad form. To these you may add a putty eraser, charcoal, felt-tip and drawing pens, a ruler and, if you wish, coloured pencils, watercolour pencils or crayons. You probably already own most of these. The putty eraser works well with charcoal, when it can become a drawing tool in its own right rather than just a means of erasing mistakes.

▽ **Basic drawing materials**

A pad of cartridge paper plus loose sheets, with pencils and a putty eraser on the left, watercolour pencils on the right, and a variety of charcoal and conté sticks plus pens.

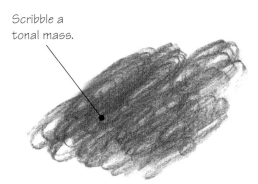

Scribble a tonal mass.

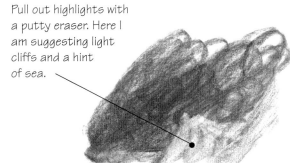

Pull out highlights with a putty eraser. Here I am suggesting light cliffs and a hint of sea.

Draw in a little detail with the charcoal, with a touch of rubbed tone in the foreground. Try other subjects from photographs or your imagination.

BUT I CANNOT DRAW!

Maybe you find it difficult to achieve a reasonable representation of your subject. Sometimes we try too hard, and we have to fool ourselves into relaxing a little. Keep a pad and pencil beside the telephone and doodle while speaking, conveniently having one or two objects nearby, or allowing yourself to enter your imagination. The results might well surprise you!

Another method is to scribble with soft pencil or charcoal, bringing the object's image out of the mass of scribble by even darker scribble, or perhaps pulling out a light image with a putty eraser. Try using

construction lines and a straight edge if you feel it would help. Some very effective artists paint in such a loose manner that their masts at times are nowhere near the actual boats, for example, so try a looser approach. While you may be able to admire this aspect in the work of others it is notoriously difficult to accept it within your own work. Gradually draw more detailed subjects. The most important point, however, is to keep practising, because you will then be improving even though it might not be apparent. Keep all your work as it is an excellent indicator as to your progress over a period.

△ If you find drawing really difficult try the scribble method using a stick of charcoal and a putty eraser on cartridge paper – it is great fun.

▽ Again using charcoal, try drawing little diagrams. Smudge with your fingers, blend, rub out and re-state until the image begins to work.

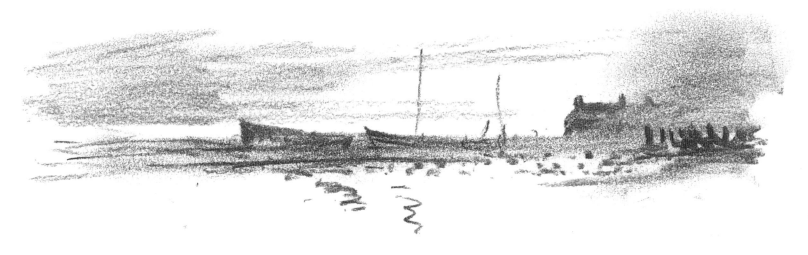

IMPROVING YOUR DRAWING

Accuracy in drawing is certainly something to aspire to, but a great many subjects in this book really do not need to be rendered precisely: rock shapes, wave structures, cliffs, sandbanks and so on vary so much in outline that absolute accuracy is not essential. Masts, the horizon line and buildings can be drawn with the aid of a ruler if necessary, but if you wish to include figures or boats, for example, you do need to strengthen your drawing expertise. The discipline of carrying out an accurate drawing, even if not vital in your current subject, will serve you well in future. It is worth setting aside a few minutes each day to practise drawing.

Drawing still-life objects such as bowls of fruit, an old boot or a glass bottle might not induce delirious euphoria in you and any similarity with coastal scenery may be completely lost on you, but such drawing is of great value to observe form and tonal relationships and how light affects features. The advantages of working indoors are that you can use an angle-poise lamp to create a variety of lighting situations and directions; you can keep the objects as simple as you wish, and add or subtract items; and you can eliminate much interference.

We all have some drawing experience from our schooldays, but sadly many are discouraged at an early age. Be assured that you certainly will be able to produce a worthwhile drawing if you persevere. If you have little experience then it is a good idea to draw all manner of objects: begin with a mug, an egg box, a bar of soap, a toothbrush, a folded face flannel, and similar objects. Seek out objects without patterns or strong colour variations and light them with an angle-poise lamp on the table beside you. Draw in simple,

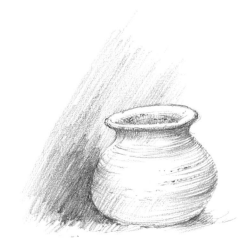

◊ Have a go at drawing everyday objects around the home for practice and include tones. Use a variety of lighting arrangements to bring out the light and shadow areas.

light outline first, using construction lines to help you with the shapes if necessary.

INTRODUCING TONE

When you are happy with the general outline you need to make the subject look solid and three-dimensional. Look first for the highlights. Where does the light strike the subject? If you leave the highlight as untouched paper you need to define it by applying tone around the light area by scribbling, hatching or rendering a darker mass of tone in some way. Once this is done apply the darker mid-tone areas, then gradually the darkest shadows. You will see the object begin to emerge from your drawing. Textures can be added if you wish to make your drawing appear more realistic. Do this with various strokes to indicate grain or surface texture.

Next, varying your eye level, place your chosen object on a box or pile of books to raise it higher. Draw it from its new position, perhaps almost at your eye level. Vary the lighting angle and try again, using light from the right, left and rear. Try to achieve

⇧ This charcoal drawing illustrates how light and dark tones suggest a sense of depth, with the strongest tone being seen near the foreground.

⇩ Take charcoal drawing a step further by fixing the charcoal on the surface with a fixative spray, then lay watercolour washes or coloured pencil over the drawing.

highlights on the object caused by the light. You will learn a lot from these exercises. Introducing tone correctly will apply to any drawing you make, whether of a single object or a scene. Use pencil or charcoal to begin with, and graduate to pen and perhaps washes of colour when you feel confident. Most essential, though, you must ensure that your pencil is always ABSOLUTELY SHARP!

FOUND MATERIAL

Once you have tried drawing these ordinary household objects – and, hopefully, others – attempt more complicated items such as draped curtains and textiles, plants and textured objects such as rough-surfaced pottery, natural wood or stone. Drawing stones, rocks, netting, shells, seaweed and perhaps detritus collected from a beach will give you more of a flavour of the coast, and hence be of greater inspiration. You may then like to try adding watercolour washes to your drawings, as watercolour

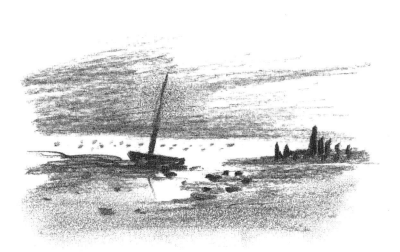

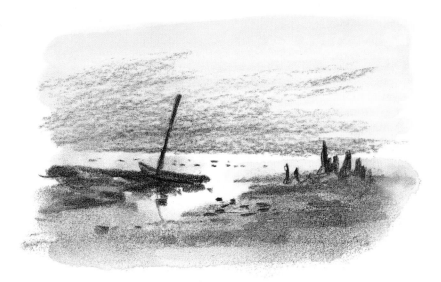

⬦ ◊ **Working from found material**

Rocks, pebbles, rope, netting and all manner of items found on the foreshore make excellent subject material from which you can create a still life.

is a natural progression, although not necessarily the easiest medium for the beginner to cope with. Alternatively, try coloured pencils; they are more controllable, yet wonderfully effective.

Choice of subject is critical while your drawing and painting skills are being developed. I have seen many students make life extremely complicated for themselves by choosing a really complex scene to paint. Picturesque fishing villages such as Polperro in Cornwall or Brixham in Devon, for example, although marvellous locations to paint, are overwhelming for the inexperienced artist, so wait until you are confident that you can render complicated harbours and boats. Uncluttered estuaries and beach scenes are more likely to afford you easier compositions.

There are many relatively easy scenes scattered throughout this book that will give you ideas on where to go.

DRAWING FROM PHOTOGRAPHS

Everyone is eager to start working on real scenery, and one way is to work from photographs. For the housebound or those who dislike sketching outside this may be the only way to work. It will give you an idea of what you will be confronted with when you are out working directly from nature. Try a simple pencil drawing of the photograph of Berneray, shown opposite. Paint it when you feel ready. Select photographs from this book or similar ones of your own to work from and build up a portfolio of subjects.

You may find that drawing a grid over the photograph is helpful, especially in the early days, with a corresponding lightly drawn larger grid on your paper to assist you in working out where each feature appears. Do not put in everything you see in the photograph – just include those features that appeal to you or that you feel should be included to make a reasonable picture of the scene. This will get you started, but really there is nothing to beat Mother Nature as a teacher, so in the next chapter we shall venture outdoors.

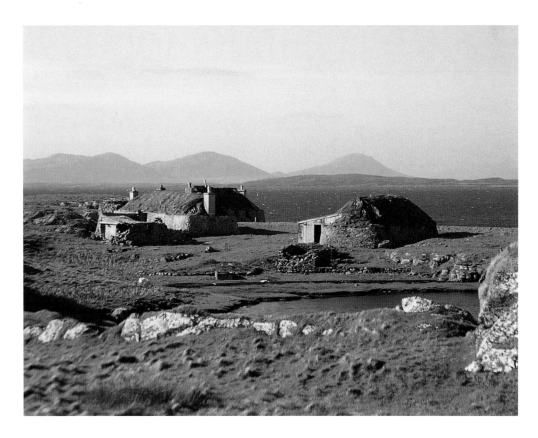

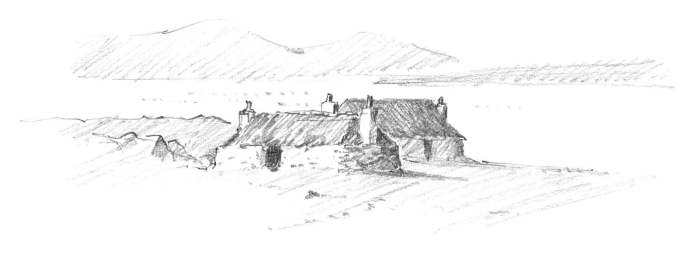

◊ ⬠ Black-houses on Berneray

Much has been omitted from the pencil drawing in order to simplify the composition. You can try a number of different versions if you wish, including just one or all of the buildings.

3 SKETCHING OUTDOORS

Being out in the landscape, touching rock, feeling rain in the face or the caress of warm sunshine, fills me with energy and inspiration. Sketching is one of my favourite activities. There is no pressure to produce a masterpiece; if I make a mess it does not matter; and being outside in front of a beautiful subject is therapeutic. Sure, at times it rains; a llama insists on drinking your painting water; someone parks in front of your focal point; you drop your Alizarin Crimson down a drain – these things happen anyway, whatever you are doing. Hopefully Chapter 2 will have prepared you for sketching outside.

These days there is a wealth of images to work from: photographs, books, magazines, postcards, calendars, and so on. However, you learn little when working from other people's images and if you enter a copied work in a competition the source is often fairly obvious. Nevertheless, I do appreciate that not everyone can get out and enjoy the landscape, and as a consequence have to paint from whatever they can find that appeals. If you are in this category you will still find much of this chapter of use to you.

You may well feel the need for a companion while working outside. If you do not know anyone, useful places to find companions are evening classes, art societies and painting courses, where students often meet people of like minds. Artists can feel vulnerable to many passing individuals, so having a companion can be reasuring.

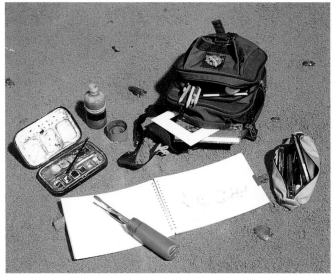

◊ **Outdoor sketching kit**

This waistbag contains a watercolour box, brushes and pencils in a plastic tube, pens in a zipped case (on right), A5 watercolour and cartridge pads, plastic clips, a small water container and a knife. A card viewfinder has been included, but I do not normally use one. I keep larger items in a rucksack.

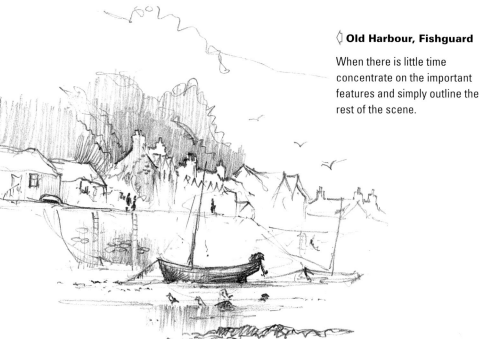

◊ **Old Harbour, Fishguard**

When there is little time concentrate on the important features and simply outline the rest of the scene.

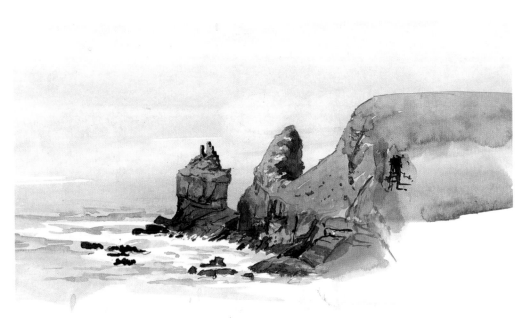

△ **Tower Point, St Bride's Bay**

A quick watercolour sketch. Note the lack of a horizon.

WHAT ATTRACTS YOU?

You will obviously paint best those subjects that particularly appeal to you. Consider what it is within the coastal areas that you would like to paint most of all. What are your strengths and weaknesses? In the beginning you will not know the answer to these

questions, and so will have to venture forth and try sketching a variety of scenery. You might loathe boats – if so, ignore them and turn to other subjects, but if you avoid them because you feel unable to draw boats then you will have to work on them. Chapter 12 covers boats in depth, but before then little pointers in some of the chapters will help you along. The same applies to water and other subjects. There are easy ways around these problems which this book aims to help you solve, but having an affinity with your subject is half the battle.

SKETCHING MEDIUMS

If you are new to sketching it is a good idea to begin with an A4 or A5 cartridge pad and a few 3B or 4B pencils. Get used to working with pencils or charcoal before tackling other mediums. A knife is essential to keep your pencil points sharp. Gradually you can expand your sketching kit to include water-soluble pencils, charcoal, coloured pencils, pastel pencils, pen and ink, and watercolour as you gain experience. Bulldog clips and elastic bands save one's sanity on windy days or even when there is only an occasional puff of wind. While a dip pen produces a better quality and variety of line, a Rapidograph-style pen with cartridges makes life easier outdoors.

FINDING SUBJECTS

Some subjects shout out to you, though most tend to need seeking out. Look for what excites you most: it may be a particular type of boat, a cottage on the cliffs, the way sunlight is falling on a group of rocks, or perhaps just the reflection of a mooring post swathed in ropes and seaweed. Using a viewfinder helps you isolate the subject from its confusing

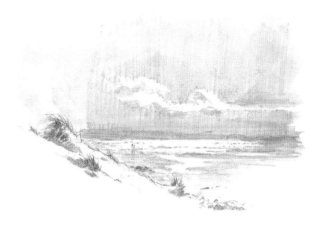

 Ynyslas dunes, Ceredigion

For moody sketches it is hard to beat water-soluble graphite pencils. Lay on the tone, then brush it over with water for some subtle effects.

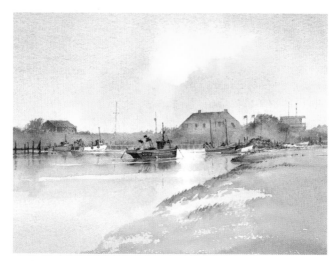

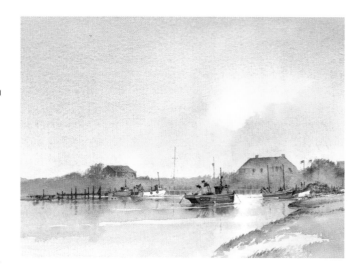

⇩ Rye Harbour
watercolour
20 x 33 cm (8 x 13 in)

There are many ways of looking at the same scene, depending on what you wish to emphasize, so give the composition some thought before beginning, whether sketching or painting.

Although the effect is pleasing, the important boats are looking out of the picture (top left). The foreground is weak and the far shoreline is just about halfway down the composition (top right). The best composition, allowing more sky (bottom right).

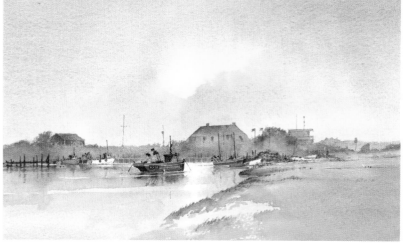

surrounds. One can easily be made with a piece of cardboard, cutting out a rectangular window of about 7.5 x 5 cm (3 x 2 in). By holding it at a varying distance from your eye you will see more or less of the scenery as suits your composition. When looking for subjects it helps to have some idea of what you are looking for, but do keep an open mind.

BEGINNING TO SKETCH

Where you start working on your paper is of great importance. I see students begin at one end of the paper and by the time they reach the other end they still have not managed to fit in the focal point, so have to place it on the next page, with appropriate directions! Even I still get this wrong at times when distracted. Begin by concentrating on the focal point using light, tentative pencil marks until you have established the main outline of your composition. Avoid using an eraser if you can because

seeing your mistake means that you are less likely to repeat it! Once you are happy with how everything fits in you can apply more pressure to the pencil and introduce tone.

If you are working in monochrome it is always a good idea to make notes on the sketch relating to the colours: 'dingy red top with a Viridian bottom' could describe a door, for example. I sometimes draw a key

⬇ ◊ **Rock arch, Three Cliffs Bay**

Compare this pencil sketch with the photograph. I inserted figures for scale when they appeared and concentrated on the area around the arch, the important area, adding colour notes for later use.

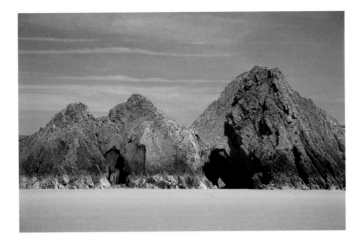

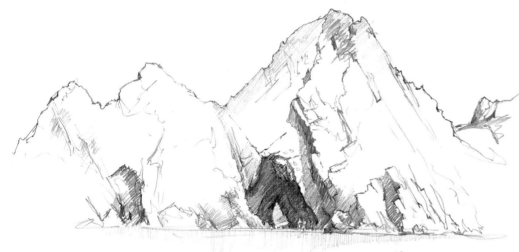

focal point too large. It does not have to fill the paper, and often a small centre of interest, with strong tonal contrasts, is more effective. Many subjects need breathing space around them, or a feeling of being in a certain setting. It is often helpful to render the scene twice – once from a distance and secondly from close-up. In this way you are recording the setting as well as more detail of the focal point, essential when the finished painting is considerably larger than the sketch.

Do have a good look around the subject before settling down to sketch as the first viewpoint is not necessarily the best. Bear in mind that subjects affected by the tide, such as boats, viewpoints that will get rather wet, harbour floors and many other features, will not stay in the same state or position. How often have I realized the tide is coming in, only when the water is above my knees, or have found myself cut off and having to wade through deep water with rucksack balanced on my head.

MAKING THE SCENE YOUR OWN

When working from nature it is not a matter of trying to replicate the exact details. There is too much information in even the simplest of scenes. Unless you are working to the strict guidelines of someone's commission, what you include is up to you. Leave out those objects that you find ugly or intrusive. Move that boat so that its mast effectively breaks up the far shore, or introduce that netting which happens to be behind your viewpoint so that when draped over harbour railings it relieves the monotony of the lines. Make the scene your own. Add figures, gulls or whatever. Change a dress from drab brown to bright red if it suits your scheme. If the focal point appears

on one side, annotated with colours linked to the diagram by arrows, if I do not wish to clutter up the actual sketch.

Outline sketches are useful, but by rendering the tonal relationships as discussed in Chapter 2 you will gain a greater understanding of the subject and hence a better chance of producing an interesting finished painting. One of the commonest mistakes students make when working out of doors, is to construct their

◊ **Ghriminis Point, North Uist**

This is a pencil study of rocks – you learn much by doing such detailed studies.

to stand isolated, think about bringing in a supporting feature such as a rock, figure, tree, mooring post, boat or similar element. The important point is to ensure that those features that you do include are well-observed and rendered with thought.

STUDIES

Look for opportunities to make studies as well as the larger compositions. Individual boats, seagulls, good examples of rocks, and even muddy channels in the harbour can make interesting detailed studies that can fit into a variety of paintings. Such a reservoir of studies is especially useful when you do not have enough detail in a sketch to complete a painting. Carefully observe the way the light is falling on the subject, how its textural qualities appear, and any nuances of colours within the main colour mass. Your studies may concentrate on capturing detailed texture or light and colour for its own sake, a useful alternative to seeking a big picture.

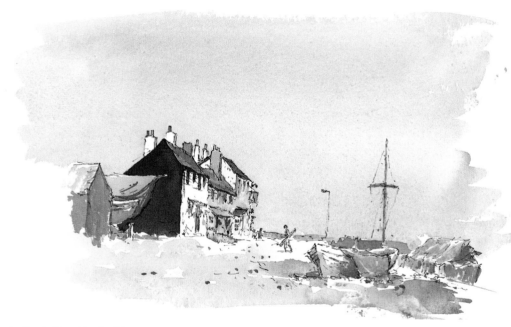

⬠ **Heybridge Basin, Essex**

The ink drawing was done first, followed by watercolour washes – an effective method for rendering buildings.

exercise 1: Working on simple sketches

1 Go out and look for a subject that appeals to you. A definite feature such as a building, bridge, rock or even a simple boat is best, sketched from some distance away – say 100 metres or more, similar to my pencil sketch at Applecross. That way you will not be bothered by too much detail or awkward perspective, unless you try the Doge's Palace in Venice, or similar! Vegetation, masses of trees, harbours, cliffs and the sea are best avoided for a while. Do a pencil sketch, adding tone. Begin with pencil sketches on cartridge paper, including tones, as in the sketch below.

2 If you are unable to get out because of weather or other reasons, try making fairly detailed drawings from photographs of coastal areas or landscapes showing a focal point in the distance or middle distance, but eliminate some of the features you consider are unnecessary to the composition.

3 Keep working on fairly simple compositions, by not moving in too close, and try some colour in the form of watercolour washes or coloured pencils.

Applecross, Northern Highlands

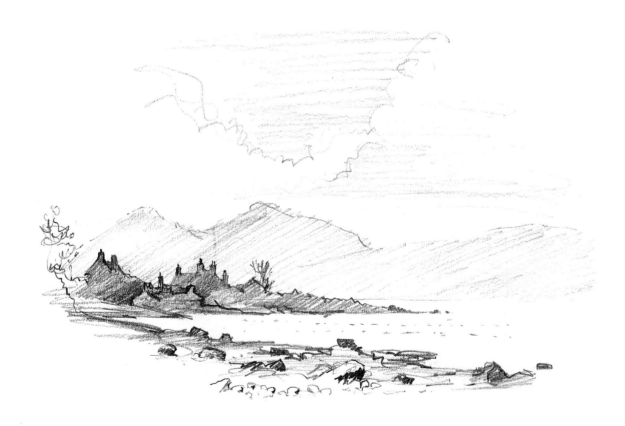

4 PAINTING WITH WATERCOLOURS

Justifiably popular, watercolour can be conveniently employed for a brief colour sketch, or a grand virtuoso performance in the studio. Even an unfinished watercolour can have outstanding appeal, and it is this wide-ranging variety of approaches and techniques that make the medium so loved, yet still a challenge for even the accomplished painter. Some of the best effects occur way beyond the control of the person wielding the brush, so it pays to be alert to exploit these accidental happenings, which are perhaps the real charm of watercolour. So often we obliterate these gems with a generous helping of mud 'because that is what was there'!

MATERIALS FOR WATERCOLOUR

If you are starting in watercolour you do not need a vast range of materials and equipment. It is better to start with a few brushes and colours, find out what can be achieved with them, and then gradually increase the range once you become more familiar with the medium. Buy a set of 24 colours and you will be totally confused unless you have had some experience. Student quality paints are perfectly acceptable until you start to sell paintings regularly. I mainly use half-pans outdoors and tubes in the studio, as tubes are more practical for larger paintings and brushes. Tubes encourage a more confident approach

if you squeeze out generous portions. The colours I recommend for beginners are:

> French Ultramarine
> Cobalt Blue
> Burnt Umber
> Cadmium Yellow Pale
> Raw Sienna or Yellow Ochre
> Light Red
> Cadmium Red

To these I would add Burnt Sienna, Gamboge, Alizarin Crimson, Raw Umber and Phthalo Blue (Red Shade) when you feel happy to extend your palette. In recent years some

◊ Quiet Mooring, Tollesbury
watercolour
18 x 25 cm (7 x 10 in)

A simple watercolour begun with Cadmium Yellow Pale in the sky and Alizarin Crimson lower down, leaving white linings. A mixture of Alizarin Crimson plus French Ultramarine was immediately dropped into the lower wet sky and below the linings, and Yellow Ochre added into the lower part of the painting. The horizon and darker clouds were made up of Cadmium Red and French Ultramarine. Posts and masts were drawn with a rigger brush and the reflections added while the paint was still damp.

◊ Watercolour materials

This shows a board with stretched paper, a mixing palette, watercolour tubes, a variety of brushes, natural sponge and a water container.

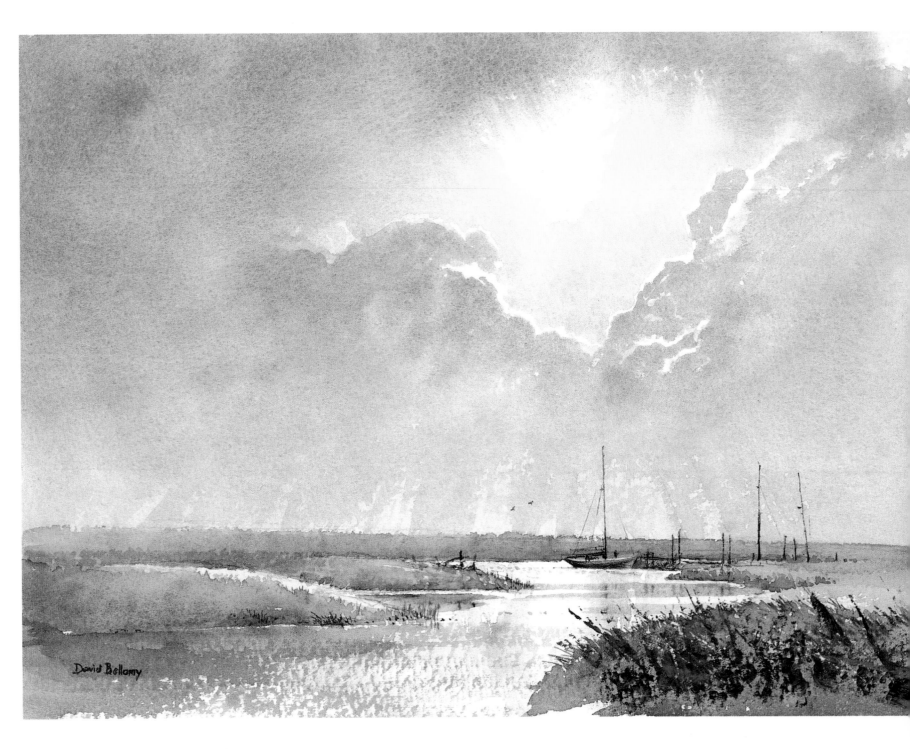

David Bellamy

manufacturers have increased the range of watercolours, taking advantage of current technology, and so you may prefer to use Quinacridone Red, a beautifully clean and transparent pigment, as a substitute for Alizarin Crimson; it is less fugitive in weaker washes but still retains many of the characteristics of Alizarin Crimson. The introduction of Perylene Red provides a strong, transparent dark red that is less inclined to create mud like the more opaque Indian Red, for example, a colour I regularly use on tinted papers. A third new colour that would make an interesting addition to the range is Indanthrene Blue, another lovely transparent pigment. By all means expand your range further as your painting develops. You will occasionally come across other colours mentioned in this book.

BRUSHES

The finest watercolour brushes have always been pure sable, but these are being challenged by the latest synthetic brushes, with the standard constantly improving. Mixtures of natural and synthetic filaments can also provide excellent brushes. You will need at least a large wash brush – the largest you can afford. Squirrel-hair mops hold a lot of water and, although they do tend to shed hairs, the good ones bed down after a while. I prefer the filbert-shaped mops as they allow greater accuracy around intricate shapes and are less prone to creating tramlines across large washes as often happens when a flat brush with square corners is used. A No. 10 to 14, plus Nos 4, 6 and 8 round brushes, and a No. 1 fine rigger for detail, will complete your range. Flat brushes are useful for certain techniques, but are not essential to begin with.

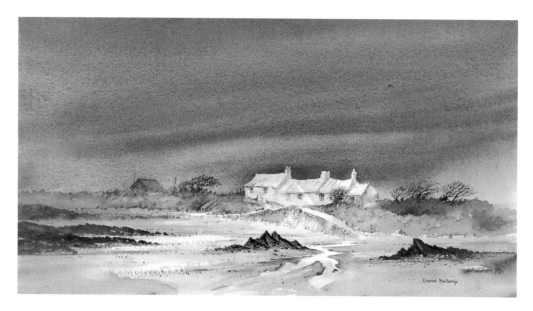

WATERCOLOUR PAPER

Choice of watercolour paper is an individual consideration. It is worth trying out a few sheets of each type of paper before settling on any one make. Buying it in sheets is usually cheaper than pads. What weight (thickness) should you get? Anything less than 300 gsm (140 lb) is rather flimsy and will definitely need stretching, as will 300 gsm if you work larger than A4. A good compromise paper might be 400 gsm (200 lb), for although it is more expensive you are less likely to need to stretch it. The heaviest paper is normally 650 gsm (300 lb), which is like cardboard. Stretching can also be avoided by painting on watercolour blocks that are glued around the edges; after completing the painting you slide a knife under the top sheet and slice it off all round. Blocks are quite expensive, though.

One of the most important features of watercolour paper is the surface texture. Some papers appear repetitive and mechanical, which I find unappealing.

△ **Cottages at Borthwen, Anglesey**
watercolour
18 x 30 cm (7 x 12 in)

I covered the cottages with masking fluid first. Once it was dry I brushed Cadmium Yellow and Alizarin Crimson across the lower sky, then swamped it with a wash of Burnt Umber and French Ultramarine, with Yellow Ochre down over the beach, leaving white areas. A mix of weak French Ultramarine and Cadmium Red was brushed diagonally over the cottages. Details were added with a rich dark mix of French Ultramarine and Burnt Umber.

Most manufacturers produce papers in three degrees of roughness: rough, which is self-explanatory; Not – meaning not hot-pressed – which is less rough; and hot-pressed, which is smooth. The rough surface is excellent where you wish to emphasize texture – a rough cliff face or sparkling sea, for example. Hot-pressed paper is superb for wash and line as pen nibs are less likely to scratch the smooth surface. It also makes a good surface for highly detailed work. The Not surface is perhaps the most popular as you can still achieve good textural effects, yet the surface lends itself to detailed work as well. Additionally, you may wish to try tinted watercolour papers. Several manufacturers produce these; most common are perhaps the excellent Bockingford range, but I also like the Australian Blue Lake papers.

You can buy sophisticated water pots and palettes, but a jam jar and white dinner plate and saucer can be equally effective. A putty eraser for removing rogue pencil lines and, of course, some 2B to 4B pencils and a drawing board are essential. You may also like to try masking fluid, a rubbery solution that is brushed on the white paper where you wish to retain a white area. Once the masking fluid is dry you can paint over it, then remove it with a finger when the paint is dry. Use an old brush, however, as the fluid can quickly ruin the hairs. Wash it out in warm soapy water immediately afterwards.

BASIC WATERCOLOUR TECHNIQUES

Take some time exploring what the medium will do. After nearly 30 years I still enjoy experimenting in this way. Paint washes, doodles and all sorts of little part-compositions on the back of letters, failed paintings or any useful surface that is handy. This will

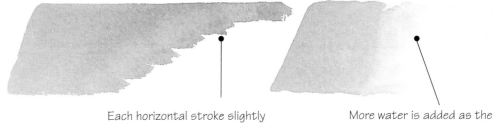

Each horizontal stroke slightly overlaps the one above, with the brush charged from a pool of paint.

More water is added as the brush moves to the right.

⌂ Laying a flat wash

In this flat wash I used horizontal brush strokes with a No. 10 sable, slightly overlapping each stroke. I have deliberately not taken the lower strokes over to the right so that you can see the brush technique better.

⌂ Laying a graduated wash

This graduated wash has been achieved by adding water as I proceed towards the right until it merges into white paper.

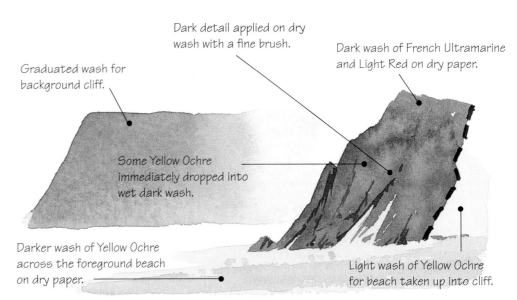

Dark detail applied on dry wash with a fine brush.

Dark wash of French Ultramarine and Light Red on dry paper.

Graduated wash for background cliff.

Some Yellow Ochre immediately dropped into wet dark wash.

Darker wash of Yellow Ochre across the foreground beach on dry paper.

Light wash of Yellow Ochre for beach taken up into cliff.

⌂ Overlapping washes

First, a graduated wash of French Ultramarine and Burnt Umber was used for the distant cliff, an effective way of making something appear to be behind a closer feature. Second, a weak wash of Yellow Ochre was applied for the beach, but taking it up to fade out in the cliff area. Third, the closer cliff was rendered by mixing Light Red and French Ultramarine. I stopped at the dotted line to reveal the weak Yellow Ochre wash. Next, while the dark cliff was still wet I added a little Yellow Ochre for interest. Finally, I introduced some stronger Yellow Ochre into the beach in the foreground.

demonstration: Chichester Harbour

Watercolour 23 x 33 cm (9 x 12 in)

On a lovely light-misty morning the calm water with its gentle reflections looked inviting – to sketch, that is. I decided to use Saunders Waterford 300 gsm (140 lb) Not paper, as there would be no strong textures but quite a bit of detail.

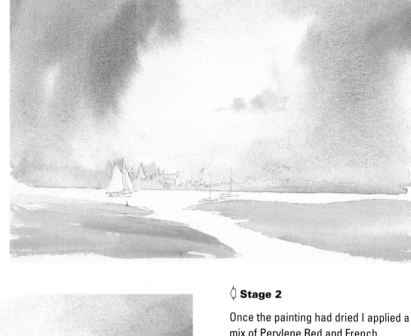

⬙ Stage 1

Using a large mop brush, I began with Naples Yellow in the mid-sky area, then merged in a mixture of Perylene Red and French Ultramarine. For the shore some Cadmium Yellow Pale was laid across, followed by Raw Umber.

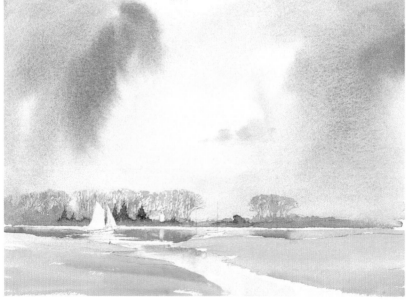

◇ Stage 2

Once the painting had dried I applied a mix of Perylene Red and French Ultramarine using downward strokes, holding a No. 6 brush horizontally to create the tree masses. I left the white gable end of the house clear and painted in the conifers using Raw Umber and French Ultramarine. The water was mainly the same mixture as the sky, dropping in darker reflections below the trees and pulling out the light reflection of the white gable with a damp brush – no colour. This technique can work well with reflections. I deliberately ignored the conifer reflections at this point, as it was too much to achieve before the wash dried.

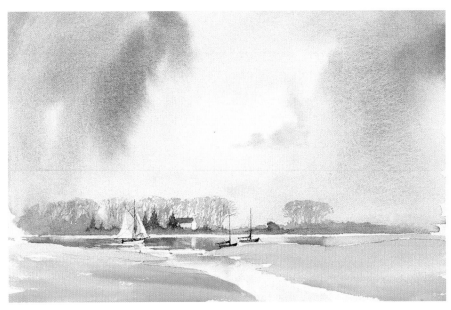

Stage 3

Once the paper was dry, I re-wetted the water below the conifers, left it for a few moments and then inserted the reflections into the damp surface with Raw Umber and French Ultramarine. Note that a large area needs to be wetted first, as the applied colour will spread widely. Re-wetting is extremely useful where you have complicated applications of wet-into-wet. The boats were then painted in.

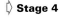 **Stage 4**

In order to make the sails stand out more I re-wetted the area around them and inserted some darker Perylene Red and French Ultramarine, allowing it to soften outwards into the pre-wetted area. The foreground banks were painted with Raw Umber and French Ultramarine, plus Lemon Yellow for the light greens. When it had dried I dry-brushed a mixture of French Ultramarine and Burnt Umber across the foreground, spattering the same mix with a toothbrush by dragging my finger across the bristles, then added some detail.

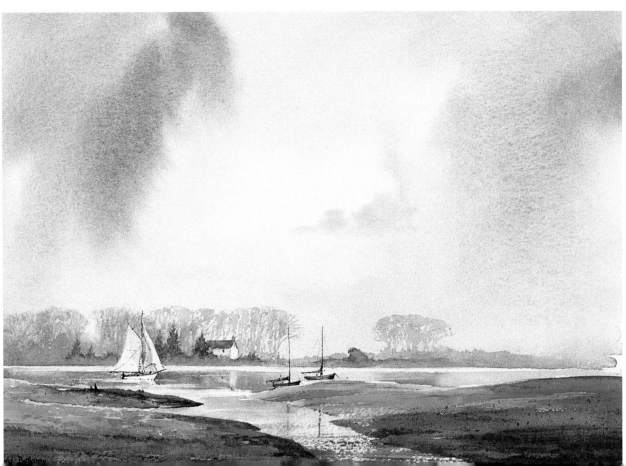

give you confidence. Use plenty of water to mix your colours. If your box contains white leave it well alone – for the moment anyway – as watercolours are lightened by adding more water, not by mixing in white as in oil painting.

LAYING WASHES

Tilt the board at a shallow angle sloping towards you. This will allow the washes to flow down the paper and be less likely to run back into that already laid and create dreadful cabbage-like creatures. Mix two colours in a saucer or palette using plenty of water to create a deep-coloured pool. French Ultramarine and Burnt Umber are a good start, making a useful grey. Beware of mixing more than two colours, especially if one or more is opaque. Work quickly, slightly overlapping each brush stroke. Remove excess water at the bottom with a damp brush; otherwise it will seep back up as it dries and create ugly runbacks that will spoil your painting.

Follow the examples shown and lay a number of washes in various colours, graduating some so that there is less paint and more water on the brush closer to the paler side.

RETAINING THE WHITES

Since watercolour is a transparent medium the artist has to work from light to dark. This means painting on the paler colours first and gradually working darker, leaving the darkest areas and details until the end. You need to be careful, therefore, about reserving any white spaces that you want to retain. You can do this by carefully avoiding the area, by using masking fluid or by the resist process where a white wax crayon or candle is rubbed over the area to remain white.

The use of white body paint or gouache is effective to detail in small features such as masts and seagulls, for example, although many artists now combine gouache with watercolour. It is especially effective on tinted papers, where no white can be reserved. Gouache is an opaque water-soluble medium.

You can also regain white areas by scratching with a scalpel or knife, but this area should be left until the painting is virtually complete. It is useful for fine lines, suggesting ropes and rigging, and straightening up shorelines where white paper depicting light water has inadvertently been splashed with colour. Avoid painting over scratches.

▷ **Negative painting**

This three-stage diagram shows how to work negatively – that is working around a light object with darker colours to define the shape. In the first stage a wash of Raw Sienna has been applied. The wash is still wet when French Ultramarine and Raw Sienna are added at the bottom in the second stage. The work is allowed to dry before the final stage where a much darker application works round the detail, fading it out higher up, where the ladder could have been made darker had I wished.

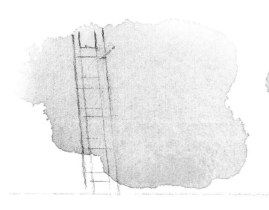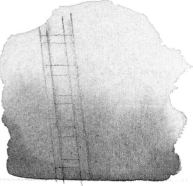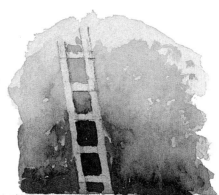

White splash – white gouache

I do not like using white gouache too much on white paper, except for the odd mast or bird, but it is included here for comparison with the other two methods. Try it – it might work well for you.

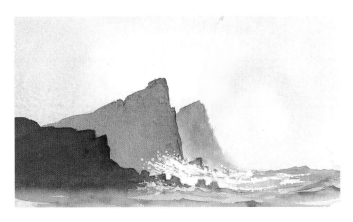

White splash – masking fluid

The combination of masking fluid and the wet-into-wet method is highly effective; the former creates hard edges and the latter, dropped into an already wet area, displays a softer approach. After applying the fluid the sky was painted and, while still wet, the further cliff was applied. Use little water with the colour that you drop into a wet area, otherwise it will seep out quickly and lose its strength and edge. When this was dry further details were added and later the masking fluid removed.

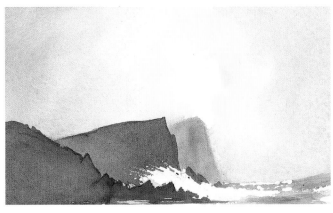

White splash – natural

Compare this with the other two versions; this is the one I prefer. Here I worked naturally around the white splash area with the brush after using the same wet-in-wet technique as above. Admittedly, I have added subtle hints within the splash here, and left them out of the one done with masking fluid, just to give you an idea of what happens.

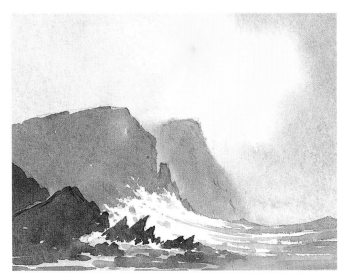

Dry-brush

This is a useful technique for creating sparkling water or rough texture, and in the latter case more effective when used over a pale colour that has dried. Ensure there is little water on the brush and experiment on the side of the paper.

PENCIL BOUNDARIES

Once you have gained more confidence work on proper watercolour paper. Try not to regard it as a painting-by-numbers exercise where you are solely thinking about the passage you are currently working on: always consider the adjoining areas before and as you apply the paint. Allow the washes to overlap, painting as though the pencil boundaries do not exist, although with some you will need to be more careful – especially those where you are retaining a white area, or where you need a pure, light colour. This overlap technique prevents ugly margins forming where two washes abut.

STRETCHING PAPER

If you use 300 gsm (140 lb) weight of paper or less you will almost inevitably need to stretch it. To do so cut four lengths of gummed tape – the brown tape that is gummed on one side – one for each edge of the paper. Sellotape or masking tape are useless for this task. Immerse the paper in water for a few seconds, then drain off the water. Lay it flat on the drawing board and stick down each side with the gummed tape, which should be slightly dampened first. Store it flat and allow it to dry out over a few hours.

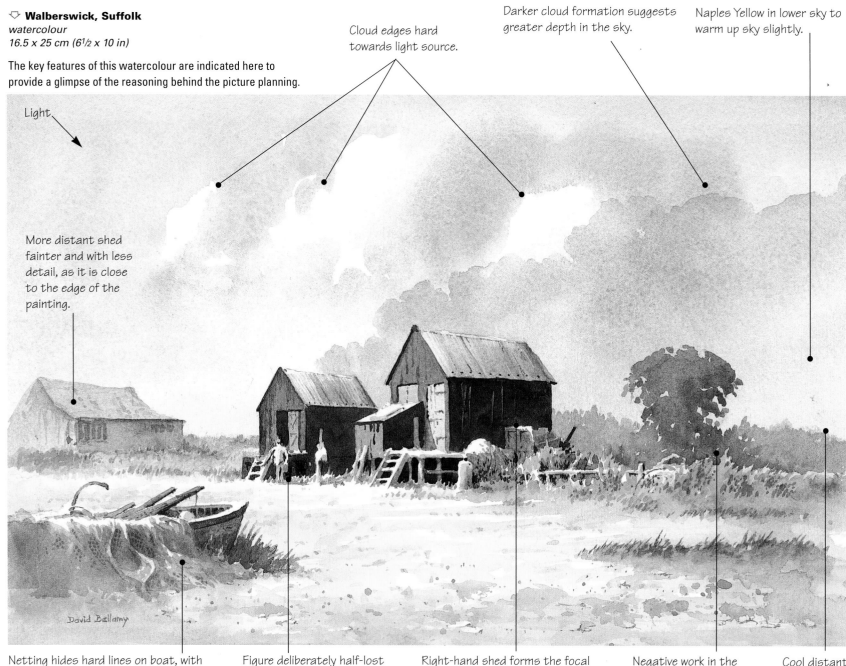

Walberswick, Suffolk
watercolour
16.5 x 25 cm (6½ x 10 in)

The key features of this watercolour are indicated here to provide a glimpse of the reasoning behind the picture planning.

Cloud edges hard towards light source.

Darker cloud formation suggests greater depth in the sky.

Naples Yellow in lower sky to warm up sky slightly.

Light

More distant shed fainter and with less detail, as it is close to the edge of the painting.

David Bellamy

Netting hides hard lines on boat, with negative painting used in places – that is, dark 'holes' define the netting.

Figure deliberately half-lost amongst shed detail so that it does not dominate.

Right-hand shed forms the focal point, emphasized by its strength of detail and tonal contrasts.

Negative work in the distance where the darker tone suggests form.

Cool distant colours.

exercise 2: Looking at detail

1 Go out and try some studies of mooring posts, seaweed, rusty chains, ropes, gulls, rocks or whatever you fancy, in various mediums. Be as meticulous as possible in rendering detail, texture and light, as this will improve your observation. If you do not live near the sea try fence posts and similar objects instead.

2 Have a go at painting from the photograph of the beach caught in evening light, keeping it as simple as you can. My watercolour is on page 118. If you are not working in watercolour try it in your own preferred medium.

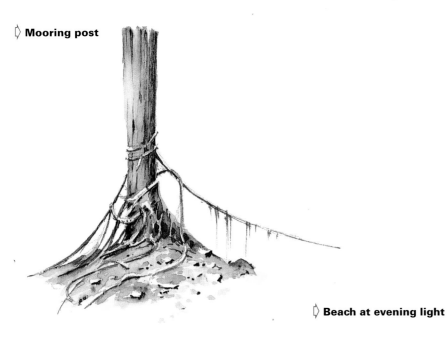

◊ **Mooring post**

◊ **Beach at evening light**

5 PAINTING WITH PASTELS

Soft pastels are a wonderfully responsive medium, allowing strong dark tones and lovely rich colours, which many find difficult to achieve with watercolours. Pastels allow rapid expression and are superb for creating atmospheric landscapes and interesting skies. The medium is messy, but this can be controlled: a damp rag or pack of wet wipes works wonders. Many years ago while demonstrating pastels at a large art show a class of schoolgirls descended upon me to have a go at pastelling. Twenty minutes later their pristine white blouses were liberally covered in pastel dust, not to mention their faces, hair, hands, etc! Take care if you are in the habit of blowing loose pastel dust off your painting, as it does not improve the flavour of your coffee!

PASTEL SUPPORTS

The single most important decision for the pastellist is the choice of support. The surface needs a certain 'tooth' or roughness to accept the pastel – the pigment will not adhere very well to smooth paper. It is worthwhile experimenting with a variety of surfaces in order to find which works best for you. Ingres and Canson papers come in attractive pads that are useful for making pastel studies and sketches. Ingres, while good for sketching is, however, a little thin for full pastel paintings unless mounted. I like the mid-greys in the Fabriano and Canson

Mi Teintes range, working on the smoother side of the latter paper, as the rough side is too mechanically patterned. Somerset tinted papers also make an excellent pastel support, and are superb if you wish to leave areas of bare paper showing, as the tints are lightfast.

Watercolour paper is also worth considering, the Bockingford tinted papers being particularly effective, although you may wish to apply an acrylic wash over white watercolour paper to tint it as you wish, or even lay a number of watercolour washes as a base, pastelling only part of the paper. Generally I prefer to buy paper in sheets rather than pads, so that I have greater choice in the size and format of the painting.

▽ **Box of pastels**

The compartmentalized box keeps similar colours together, which helps to avoid the colours contaminating each other. On the right are some pastel pencils and a variety of pastel papers.

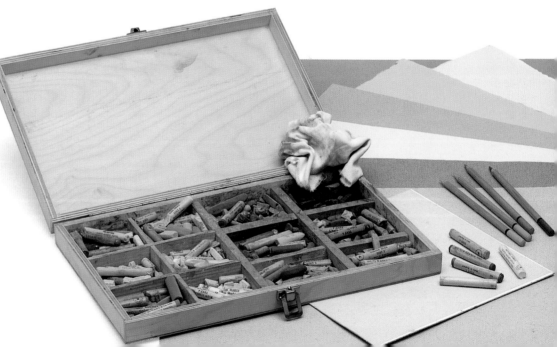

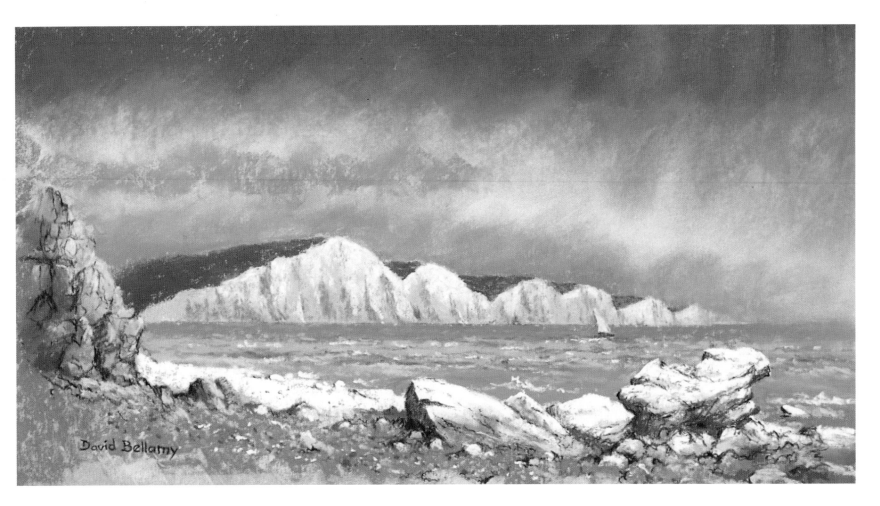

⬆ **Seven Sisters**
pastel
18 x 33 cm (7 x 13 in)

In this painting all the cliffs were rendered in a similar way, pinks and greys added, and then the far right cliffs were overlaid with grey from the sky to suggest distance. There is much pointillist dabbing in the foreground with various colours to produce an overall effect, and also some pastel pencil drawing.

Glasspaper is another effective support, although it will eat up your precious pastel sticks much quicker. Some of the thinner glasspapers need to be mounted on a backing card. Use the finest grade glasspaper, otherwise it will tear your pastels (not to mention your fingers!) to pieces in short order. Working on this surface produces greater intensity of colour. Blending should be kept to a minimum, of course, especially if you use your fingers. For practising, old brown packing paper is a cheap option.

BUILDING UP A RANGE OF PASTELS

Unlike watercolours or oil painting, where colours are mixed to form secondary and tertiary colours, you need a much larger range of pastel colours, as the mixing occurs on the painting surface. To begin with it might be best to buy a set of 36 or 48 colours, gradually adding to them as you gain experience. Throughout this book I have used Daler-Rowney soft pastels. Whichever range you use it is worth obtaining a copy of the Daler-Rowney colour chart to

compare the colours and make sense of the tinting strength of each colour.

Once you go some way beyond your initial set and start getting serious about pastel painting it is advantageous to sort out your pastels into a large compartmentalized box. There are many excellent such boxes on the market. By keeping your reds away from your blues, or your yellows from your greys, for example, the colours are less likely to be contaminated by others. How many times in the early days did I pick up a pastel, confident that it was dark brown, only to find it was actually a violent green! It still happens, but not so often. How you divide the box up depends on the number of compartments, your colour range and your preferences. You may find keeping all warm, light blues apart from warm dark blues helps, and so on. Every so often you may need to clean up the pastels. This is best done by putting the dirty pastel sticks in a jar half-filled with ground rice and shaking it briefly.

OTHER MATERIALS

For detailed drawing pastel pencils are hard to beat, but charcoal pencils are equally handy. An old brush

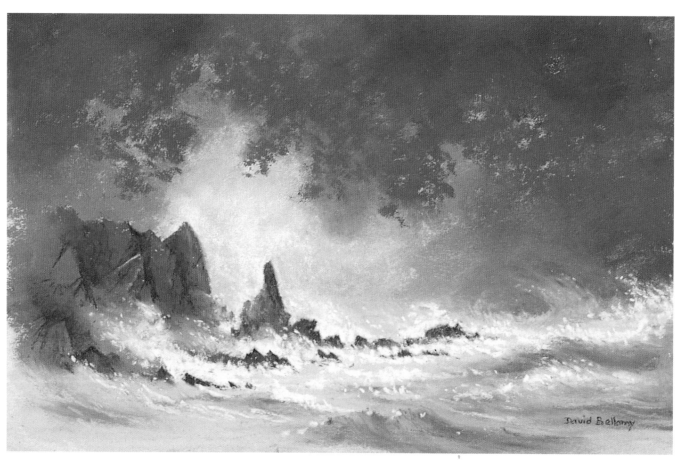

◁ **Storm, Little Castle Head, Pembrokeshire**
pastel
15 x 23 cm (6 x 9 in)

The fewer colours used the greater the unity. Storms on the coast produce a lot of white water, but try not to overdo it.

– I use a retired bristle brush – is excellent for removing areas of pastel when you want to change part of the painting. A torchon, which is basically a tightly rolled tube of paper, can be employed to blend passages, especially where you do not wish to use your fingers, or for very fine work. A square of corrugated cardboard used as a parking area for pastels in use prevents them from rolling around and creating even more mess. Rags, wet wipes and plastic transparent folders to protect your source material are all useful items. I like to have a few sheets of newspaper under the painting surface, as this not only catches much of the pastel dust, but prevents ridges in the drawing board or whatever is underneath from creating lines and marks on the thinner papers.

You may wish to use a fixative, although as this tends to deaden colours I never use it over a finished work. It can be employed at mid-stages to protect areas that have already been painted, before building up further colour over it. To store finished pastel paintings I place them between sheets of newspaper within their own folder, separate from watercolours in case pastel dust is accidentally transferred.

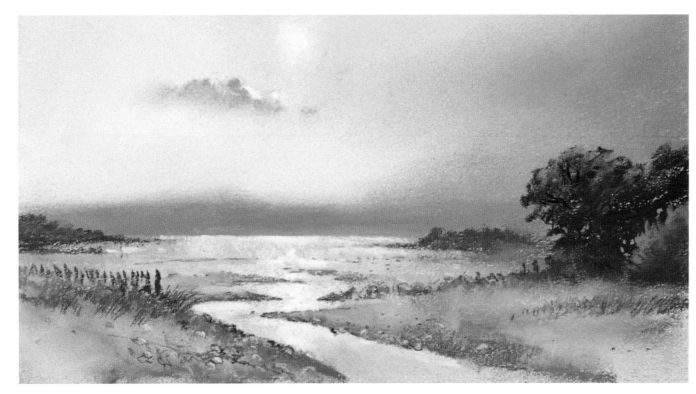

⬆ Estuary near Kingsbridge, Devon
pastel
14 x 23 cm (5½ x 9 in)

This scene has been too heavily blended, particularly in the sky, to provide a contrast with the painting of Malacleit on page 39.

demonstration: Lochside Cottage
Pastel 118 x 23 cm (7 x 9 in)

For this scene by Loch Kishorn I decided to work on fine sandpaper mounted on strong card. My aim was to produce a sunny aspect with fleecy white clouds and an overall feeling of warmth.

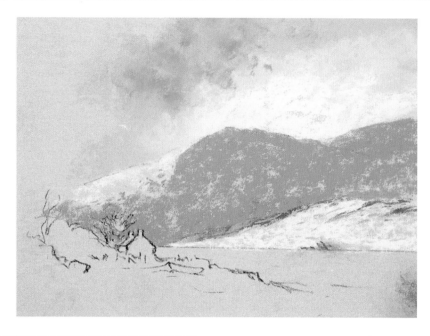

⬆ Stage 1

I applied Coeruleum tint 0 and Cobalt Blue tint 2 at the top of the sky, then Yellow Ochre 0 and Naples Yellow 2 lower down. The mountain slopes were painted with Burnt Sienna 0, Red Grey 4 and Purple Grey 2 to form the shadows and sunlit crags, with some Yellow Ochre 0 and Naples Yellow 4 applied in places.

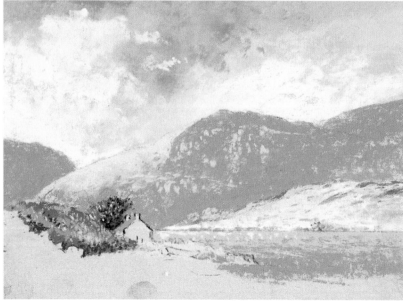

⬆ Stage 2

For the loch I used Blue Green 1 with some Red Grey 4 closer to the shore, and to the left of the cottage some Raw Sienna 6 and Olive Green 7 with Vermilion 2 on the roof. Madder Brown 8 and Cool Grey 6 rendered the tree.

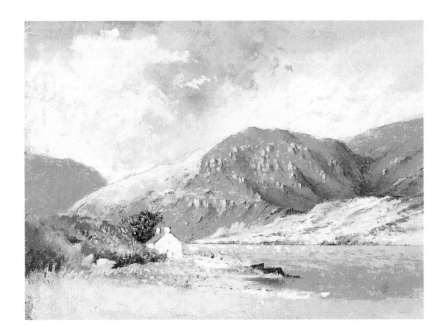

Stage 3

With Silver White I worked on the boat and the house walls. I then modelled around the boat with some Grass Green 1 and tidied up other areas.

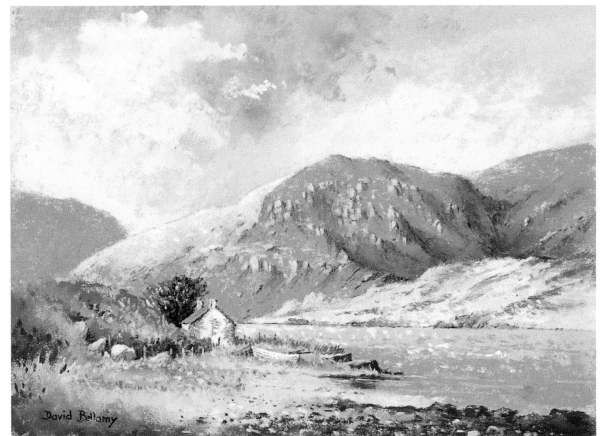

Stage 4

Some detail was added to the gable end of the building with a grey pastel pencil, then I concentrated on the foreground with strokes and stipples of various colours to suggest interest.

David Bellamy

WORKING METHODS

While it is possible to work at an easel, I feel more comfortable using a drawing board at an angle as with watercolour painting. My own preference is to work from the top of the paper downwards, as far as possible, as this is much less likely to disturb any pastel that has already been laid down, although it does help to roughly block in the main areas at an early stage. Alternatively, cover the lower part with a sheet of paper, taped to the board. Also I like to begin with the sky, which sets the mood and lighting for the scene. If you do work vertically at an easel it pays to catch falling pastel dust on an old cloth. After outlining the composition with a pastel pencil, I usually start with the medium tones, then lighten and darken areas as needed.

A generous margin on the right-hand side of the paper (being right-handed) allows me to test colours before applying them to the painting. Once I have used a pastel I keep it on corrugated cardboard to my right, so that I know which colours I have used.

PASTEL STROKES

Experiment with pastel strokes on different types of surfaces to see what you can achieve – short strokes, dabs, long strokes and more, trying the tip of the pastel as well as the side, which is best for the broader application of colour. Try stabbing and stippling as well as rubbing the pastel stick across the paper on its side and end.

Colours are added in, sometimes simply laying them against those already applied, and sometimes rubbing them into one another. By laying, for instance, blobs of yellow pastel beside blobs of blue, from a normal viewing range the viewer's eye will 'mix'

⬧ Basic pastel stroke

Basic drawing stroke, holding the stick like a pencil.

⬧ Laying a mass of colour

For a large mass of colour use the pastel on its side.

▽ Broken colour

This shows short strokes juxtaposed against each other, with some of the paper colour revealed in the foreground.

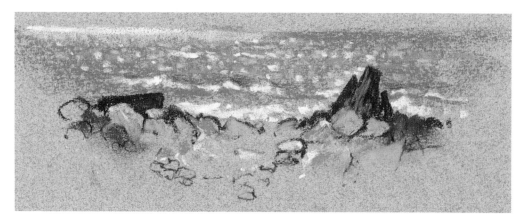

the colours into a green, the effect depending on the size and intensity of the marks. This process when taken to fine pointillism in the manner of Georges Seurat (1859–91) can be highly effective in creating the illusion of mixed colours.

Colours can also be overlaid to a degree, to produce almost a glaze effect. Flashes of 'foreign' colours, such as red into summer foliage, or bright yellow into the sea can inject a liveliness into a passage of otherwise monotonous colour. Lighten colours by adding white or a paler tint of the same colour.

BLENDING

Blending pastel colours into one another so that there is a fine transition between the various colours is a popular technique, though many pastellists feel it degrades the medium, and hence are opposed to blending. Certainly it can destroy the vibrancy of pastels if taken too far. Blending is normally achieved by applying the colours to the surface and then rubbing them together with the fingers, a torchon or even a cotton-bud. Used in excess, this method will dull the effect, and so I try to keep it in moderation. The examples in this chapter will give you some guidance on how far to take this technique.

Smudging the edges of pastel marks can be extremely effective in creating soft edges, losing hard

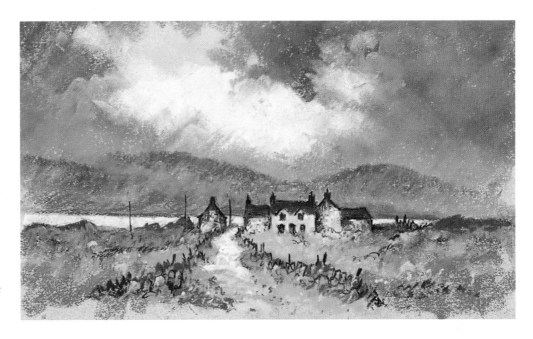

⇧ **Malacleit, North Uist**
pastel
14 x 23 cm (5½ x 9 in)

By contrast to the estuary scene on page 35 no blending has been carried out in this pastel. Judge for yourself which of the two approaches you prefer.

◁ **Negative work**

With the left-hand boat, where the white has been drawn over the background, the profile is not at all sharp. In the right-hand picture the darker colour is re-stated and effectively sharpens up the prow.

⇧ **Smudging**

Having applied the white cloud over a grey sky, gently smudging the edges of the cloud creates a lovely soft effect.

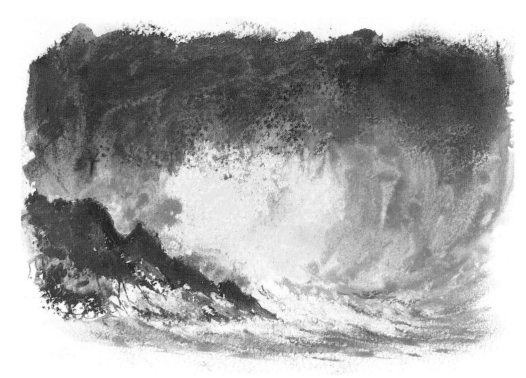

△ **Linear work**

Where the pastel has formed a wedge shape utilize it to create linear effects such as masts.

▽ **Fine detail**

Pastel pencils are superb for rendering fine detail.

△ **Using water with pastel**

Water can produce some ugly streaks over a pastel, but here I dragged dark colour out of the left-hand rocks with a sharp shaper to produce fine fracture lines, normally impossible to achieve with pastels alone.

lines, or creating a hint of atmosphere. The importance of edges cannot be overstated: hard, soft, lost and found, they all have a part to play. With pastels sharp edges can be emphasized or those you wish to subdue smudged out.

CREATING DETAIL

Attempting fine detail with pastel sticks can be likened to painting with a stick of rhubarb. Pastel sticks can be shaped to a degree by rubbing them on sandpaper to produce a chisel edge that is useful for rendering masts and other straight lines, but it is hard to beat pastel pencils for drawing in fine detail. You only need a few of the darker colours and perhaps a white and a Naples Yellow. Sharpen them to a sharp point with a scalpel-style knife or razor. There will be times when you are placing detail over, say, a darker area, or the edge is fuzzy where you need it to be sharper. This can often be rectified by working negatively; that is, re-stating the dark area adjacent to the light detail – a method often overlooked by many painting in pastel.

exercise 3: Coastal buildings

1 Try sketching a scene with just a pen – a felt-tip is ideal, but even a ballpoint will suffice. Work straight onto the paper without any preliminary pencil drawing, as I did with the ink sketch at Abereiddi. This will give you confidence. You might like to start with small studies of lobster pots, rocks, wall textures or buildings. Think about carrying around an A6 sketchbook in your pocket or handbag to sketch at every opportunity.

2 Try a pastel painting of Langstone Mill. There is no need to include every feature on the building. If you are working in a different medium then still try it before comparing your result with mine on page 119.

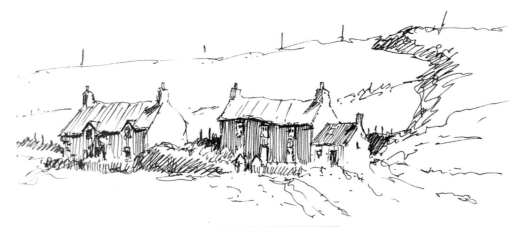

Cottages at Abereiddi

Langstone Mill, Hampshire

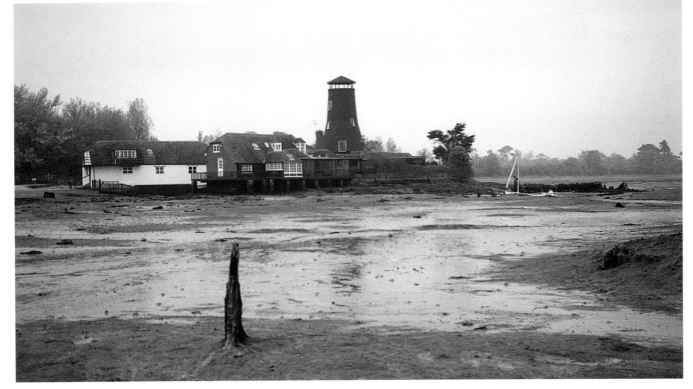

6 OIL PAINTING

The richness and versatility of oil painting cannot be surpassed by any other medium, and is ideal for those of a nervous disposition who are terrified of complicated watercolour washes. If the picture does not work, you can scrape the oil paint off and start again. Should you find the smell offensive you can use low-odour thinners to eliminate the overpowering smell of turpentine. Or, of course, you could try water-mixable oils. Naturally an oil painting takes longer to build up than a comparable work in other mediums, and it does take some time to dry, but these problems can be overcome once you have developed a method of working.

MATERIALS FOR OIL PAINTING

You will not need many brushes to begin with. A large round for painting the bigger passages, a small round, a medium-sized filbert for smaller areas, maybe a medium and small flat, plus a fine sable for detail, should suffice, all with long handles.

Choice of colours is individual, but I would recommend a large tube of Titanium White and smaller tubes of Burnt Umber, Raw Umber, French Ultramarine, Naples Yellow, Yellow Ochre, Cadmium Yellow Pale, Cadmium Red, Light Red, Alizarin Crimson, Monestial Blue, and Cobalt Blue.

Traditionally turpentine has been used as a thinner with oils, but you may prefer the low-odour alternatives that are available. 'Lean' thinners are generally used in the early stages of an oil painting, while the 'fat', linseed oil, should be added increasingly during the later stages – hence the expression 'fat over lean'. The reason for this is because paint applied with turps or turps substitutes will eventually crack if laid on paint where linseed oil has been extensively used, as thinners dry much faster. Linseed oil also tends to yellow paints over a period, so you may prefer to use a painting medium produced commercially by an art materials manufacturer, such as the Daler-Rowney Painting Medium (made of linseed stand oil, white spirit and oil of spike lavender) or Alkyd Flow Medium instead. For cleaning brushes, knives and palettes white spirit is cheaper than turps.

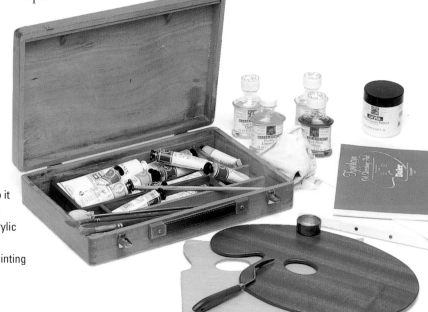

▷ **Materials for oil painting**

The box contains oil paint tubes, brushes and mahlstick. Next to it are rags, thinners and mediums, acrylic primer, supports, palettes, and a painting knife and dipper.

▷ **Ravenglass, Cumbria**
oil on canvas panel
30 x 41 cm (12 x 16 in)

The outline was drawn using weak Raw Umber. For the foreground I applied various colours with a knife, creating a strong impasto that stood up from the surface. I left the painting for a few days, then introduced a little linseed oil, keeping the rule of fat over lean. Finally, some foreground details were added, but my aim was to keep this area fairly abstract, making use of broken colour in places across the impasto.

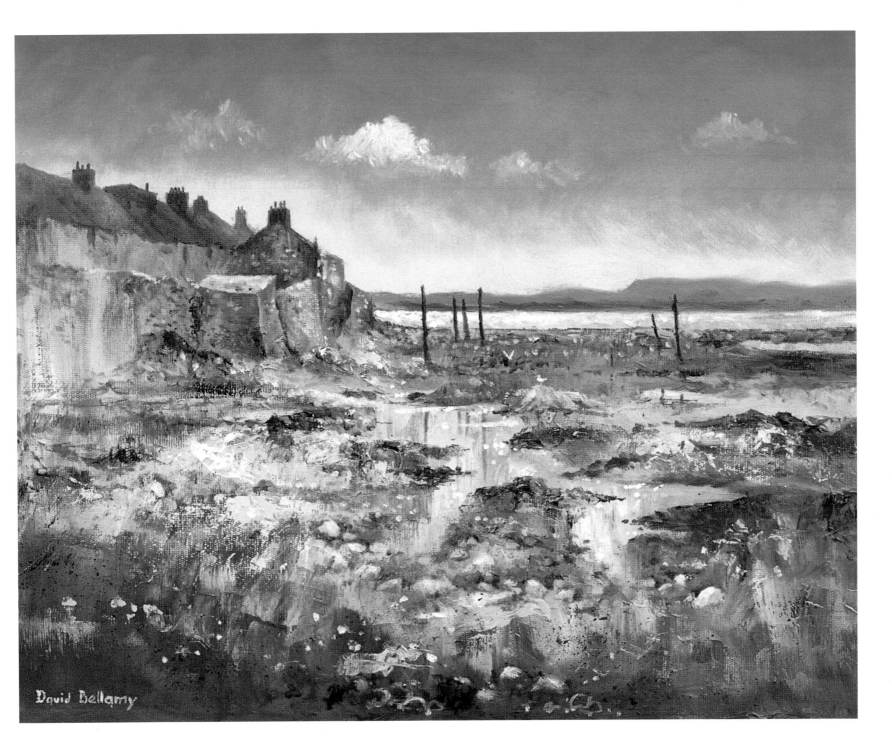

David Bellamy

Clean your brushes and equipment immediately you have finished painting to ensure they last.

Palettes come in various shapes and sizes. The traditional wooden ones normally have a thumb hole, and so are handy if you prefer to hold the palette close while standing at an easel. Tear-off palettes mean you have less cleaning to do, which makes them useful for working out of doors. Some artists use a sheet of glass over a white sheet, or a slab of chipboard covered in white melamine. A palette knife is necessary to clean the palette, as well as rags, tissues and white spirit. You may also like to try a painting knife – the ones that have a cranked handle.

OIL PAINTING SUPPORTS

Although canvases are the traditional support, many artists prefer the rigidity of canvas panels. Both types normally come with a surface prepared for immediate painting, or, of course, you can prepare your own. If you need a non-standard format or a large-scale support then you may well need to do this. Other types of support include wooden panels, hardboard, MDF and oil-painting paper such as Tyneham pads and sheets. You may like to try heavy paper or cardboard for your initial experiments, but these, like hardboard, need an application of a thin layer of size before painting. Hardboard or wooden supports should first be sandpapered. Do not use the rough side of hardboard. Traditional rabbit-skin glue size is available in sheet or crystal form, but it does need to be soaked overnight, then heated until it melts, before application. Otherwise an acrylic primer can be used, which will also seal the surface and obviate the need for separate sizing. Acrylic primer should not be used over a sized support as it will crack. Unless you are using an acrylic primer you need to prime the surface. Gesso, being inflexible, is only suitable for a rigid support such as a board. Traditional oil primer usually needs a couple of coats before starting to paint.

APPLYING OIL PAINT

Oil paint can be applied in thin washes, thicker paint or great chunks of impasto, with brush, rag, knife or whatever you have. Marks can be made by dabbing, vigorous brushing, gentle strokes, or by rubbing.

Large areas of thin paint can be rapidly applied with a rag – useful for an underpainting. When using a brush to cover large areas work the paint vigorously to avoid any speckles where gaps occur.

Do remember that if you are not satisfied you can scrape thick paint off with a knife, wash it off with a rag soaked in white spirit or turpentine, or scrub small areas with a brush, and start again.

STARTING TO PAINT

If you are new to painting in oils try working on oil painting paper, or primed cardboard first, mixing and pushing the paint around to see what can be achieved. To prevent the paper or card flying about, pin or tape it to an old drawing board. Try copying some of the simpler illustrations in this chapter. Do not worry if you make a mess – I certainly do, even now. The marvellous thing about oil painting is that you can keep tweeking it until it works. If watercolour is the cavalry, oil painting needs more of a siege mentality to win the battle. You can complete the painting at one go, but it is better to think in terms of stages and begin with the foundations.

With oil painting I usually work on a surface toned with a light wash of colour – often Raw Umber – then I draw in the composition with a fluid application of Raw Umber, using a fine brush. You can also use pencil, charcoal or whatever you are most comfortable with. Bearing in mind the 'fat over lean' principle, the main colour areas can then be blocked in with a rag or large brush, using thinners to aid the washes, although the paint can be applied directly from the tube. It is helpful at this stage to consider where any areas of broken colour will appear, as the foundation layer will show through any broken colour in places. Often this painting stage will be over in minutes, then the picture put away for another day. There are times when I return to the painting totally unimpressed by my efforts, and then completely change the lighting, the tonal relationships, and even major features of the work. Happily, oils can cope with these changes of mood!

COLOUR MIXING

Unlike watercolour where water is used to lighten a colour or mixture, this is achieved in oil painting by adding white. Mixing too many colours together will create mud: try to get as close as possible to the colour you require by mixing just two colours, adding a third only if necessary, and then only a hint of the colour. At this point you may then need to adjust the tone by adding white to lighten, or more of the darker colour to darken the mix. I rarely use black for this as

▽ **Applying large areas of paint with a brush**

Whether painting with neat paint or with the aid of a medium, large areas should be applied vigorously with a brush, so that the paint is rubbed into the surface. This is particularly important in heavily textured supports such as medium or rough-grain canvas. Work the paint in several directions.

◁ **Applying large areas of paint with a rag**

A rag soaked in thinners is the quickest way of laying a thin colour wash across the support, and is especially useful for skies, for example.

demonstration: Bradwell-on-Sea, Essex

Oil on canvas 30 x 14 cm (12 x 5½ in)

Rain was skitting down while I did the original sketch, so I wanted to give the impression of a fresh day, keeping the composition fairly simple. For a support I chose a stretched canvas.

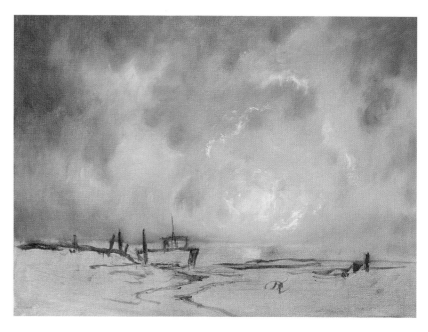

▷ Stage 1

The outline drawing was done with weak Raw Umber applied with a fine brush over an undertone of the same colour. I then whirled the sky on with a large round brush, using a mixture of French Ultramarine and Flake White, then some Cadmium Yellow Pale and Naples Yellow for the highlights. In the top left corner a sombre mix of Burnt Sienna and Ultramarine lowered the key a little.

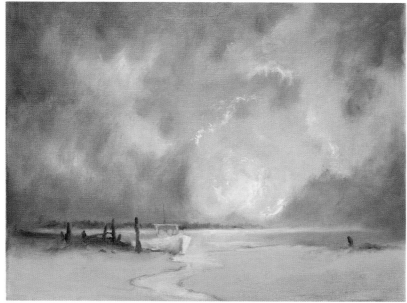

◁ Stage 2

Naples Yellow was applied to the foreground, then Titanium White, French Ultramarine and Yellow Ochre in the estuary with hints of Cadmium Yellow Pale. The boat was mainly painted with Titanium White, then a mixture of Raw Umber and Ultramarine to render the posts.

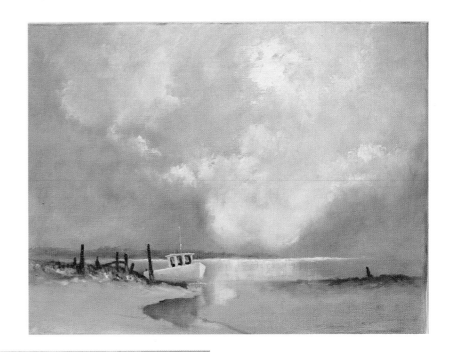

Stage 3

The sky was lightened with Naples Yellow and Titanium White and other colours added for interest. Using the edge of a painting knife, I then applied the white mast.

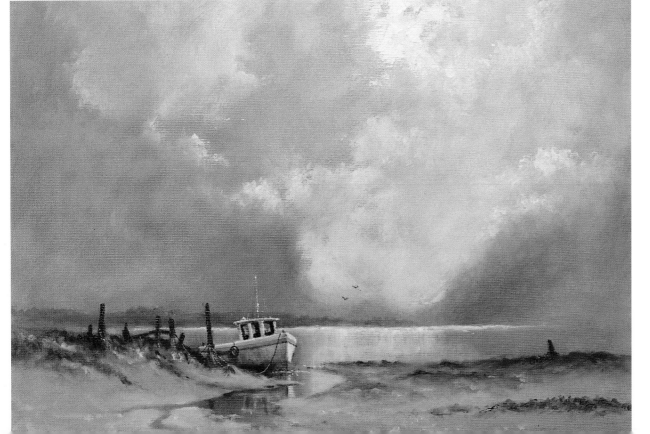

Stage 4

Here I darkened the hull and added a Cobalt Blue line along the boat. Even if the boat does not have such a line it is worth inventing one sometimes, as white can become a little boring in excess. Finally I painted in some Naples Yellow and Titanium White in places within the foreground.

it is such a dead colour, and prefer to mix a 'black' from dark tones.

The only way to learn colour mixing is to actually do it, playing with the colours, lightening and darkening each mixture as you proceed. You can produce a colour mixing chart by working methodically on a large board primed with a white surface, recording different colour mixtures and assessing what works best for you. As you buy new colours add them to your mixture samples.

DEVELOPING THE PAINTING

For the large areas of a painting I use vigorous strokes of the brush to push the paint into the textured canvas surface, at times so much that the whole easel is rocking like a three-master in a force ten gale. If you find that the paint is skating around on a surface that is still wet, leave it to dry and continue the painting at the next session. Building up the composition gradually, yet covering much of the painting area each time, allows you to check progress and correct any mistakes.

Although you are working in an opaque medium you will find that, just like pastel painting, certain features will benefit from negative painting. This is more generally thought of as a watercolour technique, where dark areas are painted around a light feature to make it stand out. In oil painting you may well find that while working on a tree the light trunk has too ragged an edge. By re-stating the dark passage beside the trunk a better edge might well result.

Where you feel strong texture might be introduced try working in two stages: during the first session apply thick impasto blobs, streaks or whatever shape is needed, then at the second stage when the impasto has had time to dry you can brush across other colours. Impasto creates interesting surface texture. Do bear in mind, though, to include more fat in the form of medium during any overpainting as per the 'fat over lean' principle.

KNIFE PAINTING

Many students shy away from knife painting, but with practice it can become an extremely useful tool.

▷ **Duart Castle, Isle of Mull**
oil on canvas panel
30 x 41 cm (12 x 16 in)

The main blue used in this painting is Cobalt Blue, which I used with Alizarin Crimson for the mountain. Lower down I painted the trees with Viridian mixed with Raw Umber and the grass with Viridian mixed with Cadmium Yellow Pale.

▽ **Using the edge of a painting knife**

This shows how a straight line can be achieved by applying the paint with the edge of a knife – but practise it first!

▷ **Applying impasto with a knife**

Thick masses of colour can effectively be spread on to the surface by using a painting knife with a cranked handle. This method can provide an interesting base layer on which to create texture by overpainting. Note that if you do paint over this impasto you need to mix in more oil, otherwise a lean layer will crack over the impasto when dry.

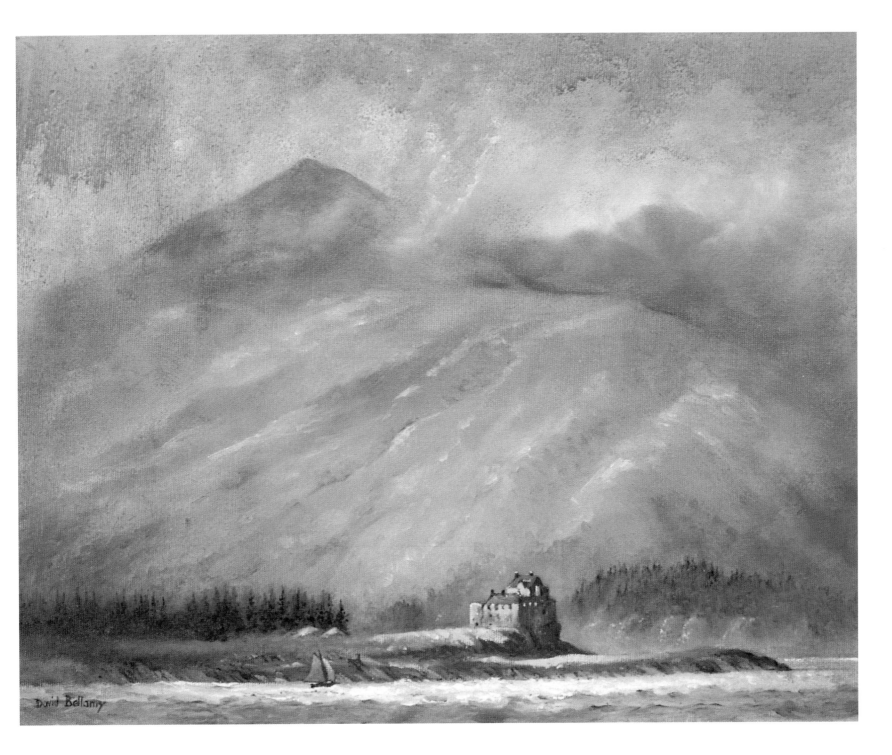

David Bellamy

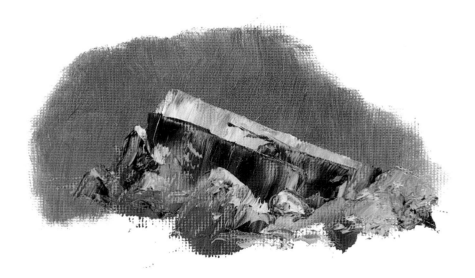

⬆ Combining brush and knife work

The sharpness of the edges created by painting with a knife can easily be seen in this oil sketch, where some brushwork has been introduced in places to soften shapes.

Painting with a knife tends to produce a cleaner application of paint, although picking up a variety of colours and laying them on with one flourish creates interesting effects that are impossible to achieve with a brush. Heavy impasto is easier to render with a knife, although you could use a trowel, spatula, or shaper. A painting knife is also superb for creating hard and straight edges, and on its side the knife can produce strong linear effects, excellent for creating masts, aerials or telegraph poles. I often employ a knife for rough ground or rock scenery, blending it with a brush in places to create an interplay of hard and soft edges.

A knife is also useful for the sgraffito technique, where wet colour is scored by a blade to reveal the underpainting. This method does need forward planning, to first lay on the underpainting and then at the next session apply another layer before scraping with a knife or shaper. Being softer and less sharp, shapers create an image with quite different character to the knife.

▽ Sgraffito

Here Naples Yellow was applied to the upper section of the wall, and Viridian to the lower. This was left to dry for a few days, then a mixture of French Ultramarine and Raw Umber painted over the wall. I then immediately scratched the rope lines with a knife in the centre and a shaper for the two right-hand lines. Because of the earlier painted areas, the ropes appear to change from yellow to green as they descend. I also rendered a fine netting effect on the left with a knife. The marvellous thing about using this sgraffito technique is that if you make a mistake you can simply repair the dark colour and try again. It works best when planned, as in this approach.

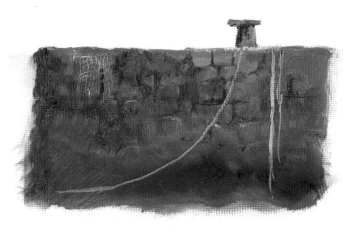

▽ Pointillism

Like pastel, oil painting can be enlivened by the use of stabbings of colour painted in this way. Observe especially the colours and patterns on pebbly beaches.

exercise 4: Emphasizing your centre of interest

1 Try sketching buildings, beginning with ones seen in the distance, similar to that in my sketch of Vallay Strand, and include some of the adjacent features. Gradually work from a closer range until the building takes up most of the paper. Then try other buildings. In each case consider which version you like best, and why.

2 Do a painting of Church Rock from the photograph, trying to retain the lively sea effects and the way in which the sunlight is hitting the rock. This emphasizes the centre of interest. My painting is on page 120. If you do not wish to work in oils try it in your preferred medium.

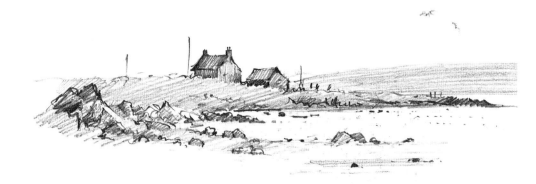

⬔ **Vallay Strand, North Uist**

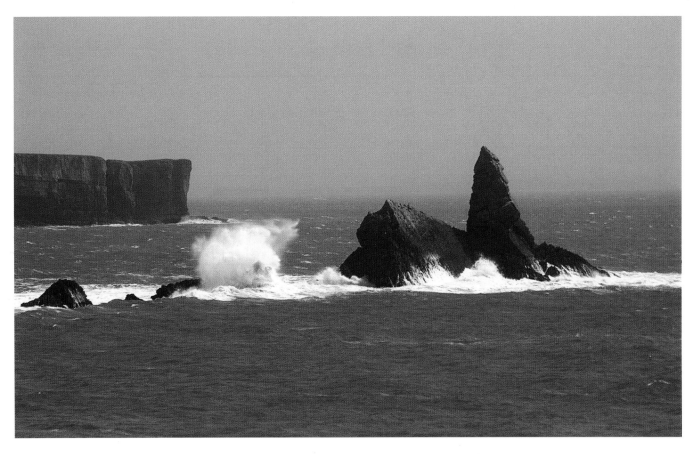

◁ **Church Rock, Broad Haven**

7 COASTAL LANDSCAPES

With such a wide variety of coastal landscapes there is always much scope for the landscape artist. Estuaries, cliff-top views of bays, sea-lochs with mountains, coastal marshes and tidal creeks all generally give you a less cluttered landscape and are excellent material for your early attempts. This chapter concentrates on the more simplified compositions, leaving beaches, boats, harbours and the sea itself until later in the book.

GENERAL LANDSCAPE COMPOSITION

When working from a sketch or photograph the composition has already been worked out to a degree. However, the artist needs to see if it can be improved, or if certain features should be changed, moved, or

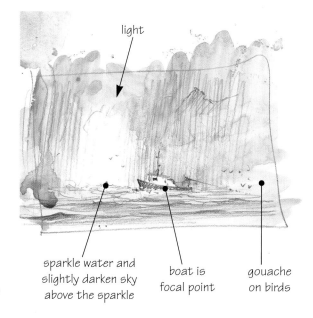

light

sparkle water and slightly darken sky above the sparkle

boat is focal point

gouache on birds

◊ **Studio sketch**

This rough studio sketch in pencil and watercolour illustrates how useful a wash can be to suggest darker parts of a painting – in this case atmosphere. It is well worthwhile planning a painting with a studio sketch, and essential when the subject is complicated.

▽ **Farm on the Wash**
watercolour
10 x 30 cm (4 x 12 in)

This elongated format makes a pleasant change from the normal rectangular format, and placing the focal point in the middle distance keeps the painting fairly simple.

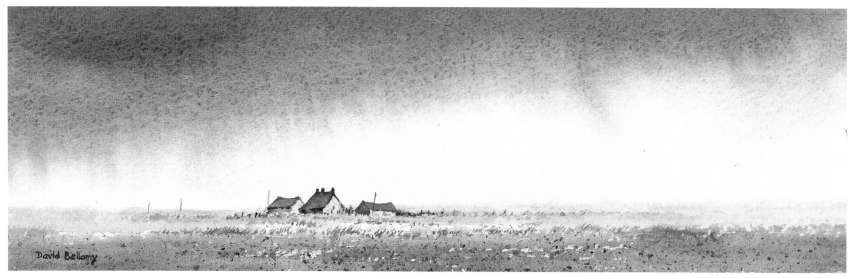

David Bellamy

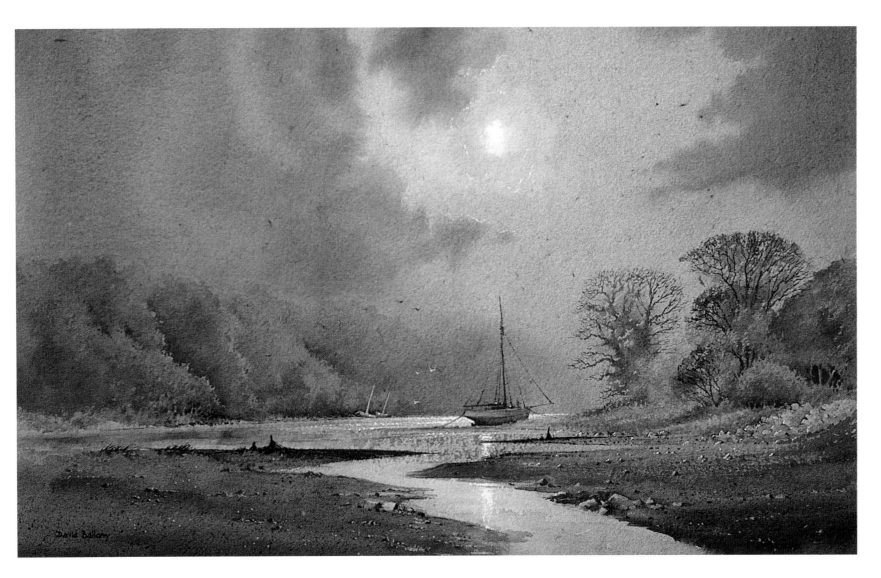

⬦ **Gweek, Cornwall**
watercolour and gouache
32 x 44 cm (12¹/₂ x 17 ¹/₂ in)

The limited palette emphasizes the moody creek, the highlights brought out with white gouache. The paper is Australian hand-made 300 gsm (140 lb) Blue Lake, using the rough side.

perhaps others substituted. There may be no need for any alteration, but if there is you may find it helpful to draw out a studio sketch before beginning work on the painting, as this can set things clearly in your mind. Where you are introducing features from additional sketches or photographs this studio sketch becomes essential.

It is worth asking yourself a number of questions at this point: What is my centre of interest? How can I emphasize it or make it stand out? How large should I make it, and where on the paper should it appear? Can I support the centre of interest with other features, and if so, what? How can I suggest a lead-in for the viewer's eye to follow up to the centre of

interest? Do I want a lot of sky, or should I keep it minimal with a high horizon, or perhaps eliminate it altogether? Is most of the detail on one side of the painting, and if so how can I balance the composition on the other side? A studio sketch, or perhaps several sketches, will help you assess these problems.

Many artists, especially beginners, are too literal with their compositions, and feel they must place everything exactly where it stands and not leave out a blade of grass. It is not a matter of trying to replicate a photograph, however, but to stamp something of ourselves on the subject. So it is perfectly permissible to move things about and get rid of that ugly rusting sand-dredger, for instance, and replace it with a sailing dinghy if you wish. However, in the right light even the ugliest of sand-dredgers can have a certain appeal.

SUBJECT TREATMENT

Once you are happy with your composition it is vital to consider how you intend treating the subject before diving in with paints or pastels. Where is the light coming from? How will the direction of the light affect your focal point? In other words, consider which aspects would best be in shadow and which in light. This may well affect a number of features. What sort of sky will work best – cloudy, bright, warm, cool, sunny or perhaps an approaching rain squall? As the sky sets the mood and affects the lighting arrangement this is a particularly important point. How will the focal point appear against the background? Will it be darker or lighter in tone, and to what degree? When you have answered these questions you will have a better idea of which colours to use and, most importantly, how the tonal areas relate to each other.

EARLY DAYS

Those who are new to painting landscapes or are dissatisfied with their current work will benefit from seeking out the less demanding landscape. Many students tend to home in on a complicated focal point, such as an intricate building, and make life even more difficult by rendering it close up in great detail. Standing away from your subject and making it a more distant feature will inevitably simplify life, as the exercises in Chapter 3 were designed to accomplish. Distance often lends enchantment, for how often have I sketched a superb scene from far away, only to find on closer examination that the 'interesting' textures by the old barn turned out to be a revolting heap of rotting refuse!

BOATS AND WATER

Boats and water can be especially troublesome for the beginner to render. Keep boats at a distance or extremely simplified and practise the techniques illustrated here.

In order to make your water look like the real thing there are a number of devices that will help. First, water is flat, so even though you may see sections of

▽ **Simple boats – afloat**
watercolour

These boats have been kept as simple as possible, painting each from a different angle. Take care of their relationship with each other where you have a number involved, as the perspective can be thrown out of key, especially by boats at many different angles. All reflections here were painted wet-on-dry.

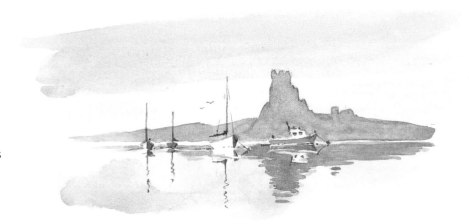

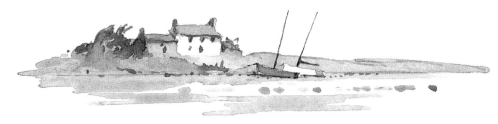

▽ **Simple water, with Arab fishing craft**
watercolour

The water here is simply light and medium toned washes brushed horizontally across hot-pressed paper, but a Not surface will work equally well. The fishing boat reflection is a weaker version of the sail colour applied on dry paper.

△ **Simple boats – aground**
watercolour

These are just about the simplest boats you will find, involving just an outline and a mast. I often use simple boats in scenes like this, as they make an excellent focal point. At times adding little figures by the boats can strengthen their appeal.

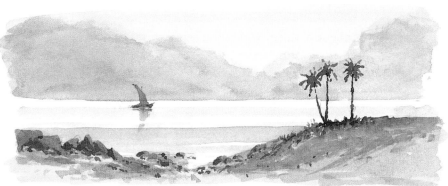

▽ **Simple water – dry-brush technique**
watercolour

The dry-brush sea has been rendered with hardly any water on the brush. This is a quick way of creating a simple water effect and looks best applied to rough paper.

water boiling up into waves and down into troughs, you must keep the general line of water flat. Second, reflections are a powerful ingredient in suggesting water: they only need be partial or hinted at in some way. Third, water tends to catch the light and colours, so particularly watch out for the opportunity to introduce flecks of white here and there, making them increasingly larger as they get closer. Watch those colours – even brown or yellow water should look like water.

At some stage you will be confronted by a straight distant shoreline or horizon, so to avoid any embarrassing banana-shaped shorelines you may like to use a ruler or straightedge. Bays and scenes viewed from cliff tops are another source of potential downfall (no pun intended!) as the perspective is usually more complicated when looking down on a subject, so try to work from near sea level, especially while you are learning.

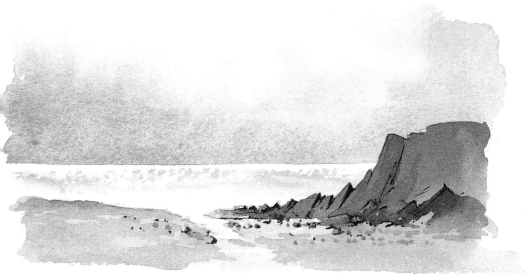

demonstration: Porlock Weir, Somerset

Watercolour 23 x 30 cm (9 x 12 in)

Porlock Weir has many delicious corners for the artist, and this is one. It can be painted with or without the boats, so if you dislike them you know what to do! However, as one does rather trip over them, I decided to include a few in this watercolour on Waterford Not 300 gsm (140 lb) paper.

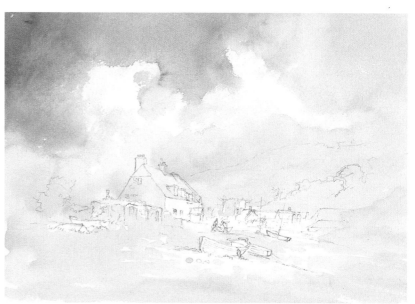

▷ Stage 1

I washed in a sky of Indigo, adding in some Cobalt Blue in places, leaving white clouds. Next, I introduced Yellow Ochre into the lower parts, bringing it down into the foreground, but leaving further whites in places.

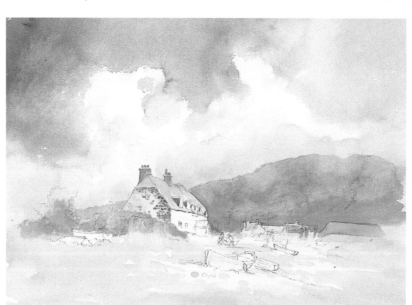

◁ Stage 2

Sticking with Indigo, I mixed it with Raw Umber, then washed this over the hill with some Yellow Ochre in the bottom. The gable end of the house was rendered with a mix of French Ultramarine and Raw Umber with further Yellow Ochre droppings while still wet.

Stage 3

The trees were inserted with the same dark mixture of Raw Umber with Indigo before some Light Red was applied to the roof of the building.

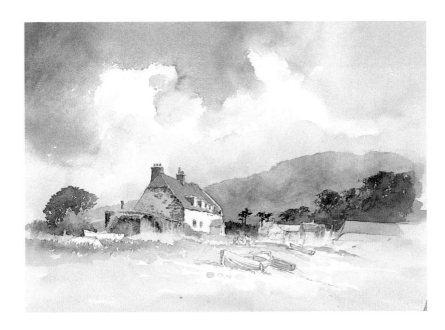

Stage 4

In this final stage, using French Ultramarine with a touch of Burnt Umber, I painted in the shadow areas thrown by the boats and gable, plus some of the right-hand buildings. This was followed by working on several detailed areas, including the figures, harbour wall and boats, with some Cadmium Red on the main one. The foreground was deliberately left high-key to suggest bleached sunlight.

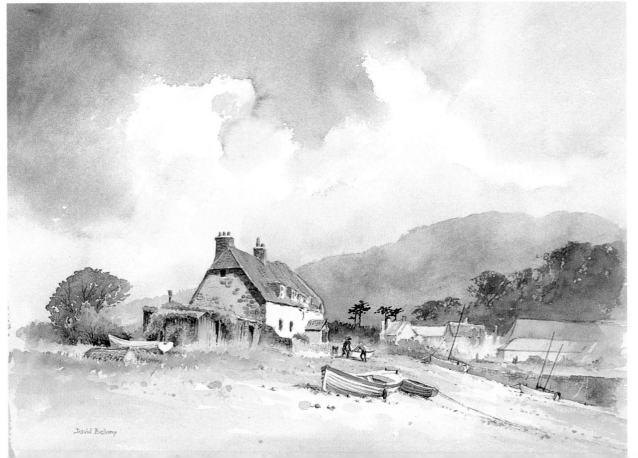

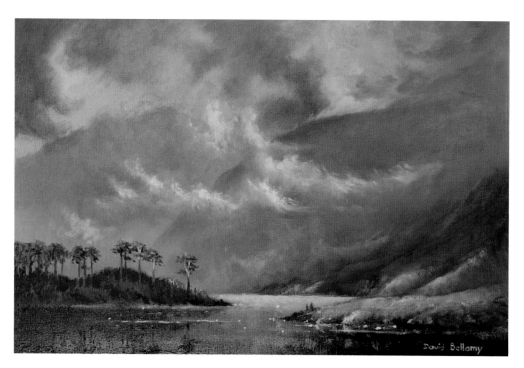

◊ **Mawddach Estuary**
oil on canvas panel
25 x 36 cm (10 x 14 in)

Halfway through this painting I completely changed the sky. My main aim was to accentuate the atmosphere and create a sense of sunlight cascading down from the top left, to catch the top of the pines.

FOREGROUND PITFALLS

The foreground in a painting is commonly felt to be a potential disaster area, liable to considerable overworking. There is no set formula as so many variables enter the equation. Sometimes the focal point can be placed in the foreground, but more commonly in a landscape it is situated somewhere in the middle distance. In this case the foreground area has a number of functions. First, it can provide a lead-in to the focal point in the form of a lane, stream, fence, wall, or many other features generally forming a linear approach towards the centre of interest. Second, the foreground can suggest depth in a scene, usually by containing features with warmer colours and stronger tones than those in the distance, although this is not always true. Depth can also be indicated by having a more detailed area in the foreground. Third, the foreground can include objects that provide a frame through or past which we can view the focal point – a tall tree or cliffs, for example, generally rendered quite dark in tone.

It is easy to overwork a foreground in any medium and produce mud-like passages that detract from a

▽ Overy Marsh Creek, Norfolk

My photographs of this scene did not do it justice, yet my pencil sketch captured the haunting appeal that is so common to these flat marshy regions. Sometimes it is worth sketching a scene even if you are unsure whether it will be usable.

Evening, Aberdyfi
watercolour and gouache
23 x 30 cm (9 x 12 in)

◁ Here the painting, again done on Blue Lake tinted paper, has been brought almost to conclusion so that you can see how it appears before the highlights are added.

▽ This is the final version where the white gouache highlights have been rendered, bringing the scene to life. Note how the distant harbour wall and buildings have been painted without detail, simply as a flat wash, even though some detail was visible.

painting. Sometimes the wrong colours are used, and there is a need to go over the passage again with a different colour. To obviate this affliction test the colours on scrap paper first, though in oils you can wipe off the offending area with a rag and start again. Other ways in which a foreground may be overworked include not getting the tone dark enough at the first attempt, so another layer is put on. Try to get the tone right first time. This can be difficult in watercolour as the pigments lighten to some degree as they dry. I often lay a foundation colour on first and during the latter stages of the painting place broken colour over it, allowing some of the original colour to show through in places. This works well in all mediums, but is especially prone to excessive fiddling: too much pastel and it will not stick to the support, and in watercolour too much brushwork is a marvellous

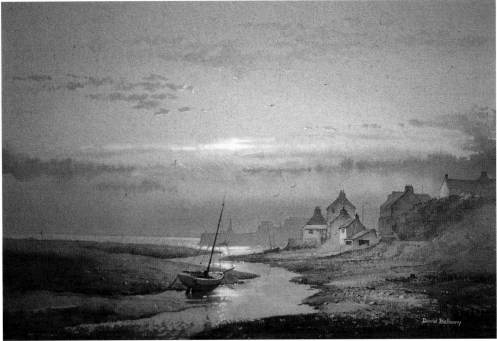

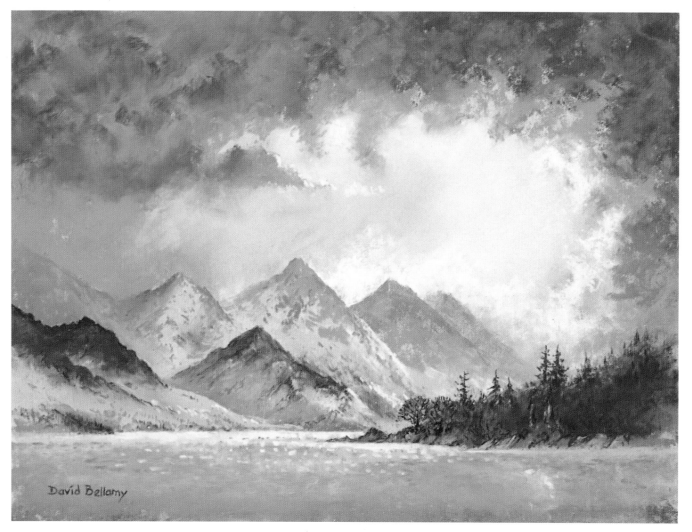

◊ **Loch Duich, Western Highlands**
pastel
20 x 28 cm (8 x 11 in)

Pastel responds well to this fine glasspaper. The original scene was sketched from a boat, viewing the Five Sisters of Kintail from Loch Duich and using the right-hand tree mass to frame the focal point. A hint of colour in the right-hand sky relieves the overwhelming greyness.

David Bellamy

recipe for mud! Hence it helps to use as large a brush as you can.

A certain amount of detail in the foreground can be attractive, but too much can overwhelm a painting. This book is filled with paintings employing a variety of approaches to foreground detail and it would help you to study them from this point of view. Masses of repetitious detail can become monotonous. On occasion a completely flat foreground devoid of any detail will work, but mostly I like to include a few elements of strong detail, often supported by suggested detail and with fairly large areas where nothing is happening. Shadows cast across the foreground work well and introduce variety. Detail can also be reduced by the vignette technique described on page 71.

exercise 5: Tackling foregrounds

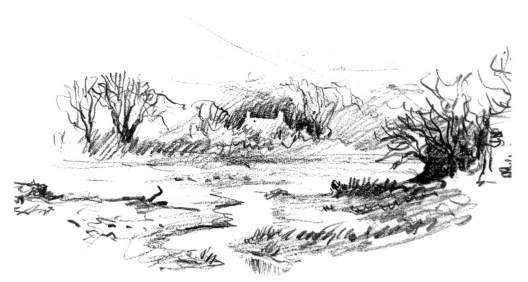

⬆ **Nyfer estuary**

⬇ **Brancaster Staithe, Norfolk**

1 Look for a scene with a focal point in the middle distance and make a number of sketches of it, each with a different foreground. There is no need to render the focal point in any detail – simply indicate it broadly and concentrate on the foregrounds. Try to make them as varied as you can by moving around, but still keeping the focal point visible. My sketch of the Nyfer estuary is the sort that provides much scope for a variety of foregrounds and treatments.

2 Find a scene such as an estuary with hardly any obvious features and make a sketch trying to generate as much interest as you can.

3 From the photograph of Brancaster Staithe in Norfolk try a painting, reducing the amount of background features and keeping it simple. If you prefer, leave out the large boats, but it might be worth including one or two distant ones to give a sense of place and act as support to the focal point, which could be one of the more prominent buildings, or a boat. My watercolour of the scene is on page 121.

8 PAINTING ON SITE

For many artists, carrying out a full painting out of doors is the only way to work. There is nothing quite like working directly from nature, and in the right conditions it is hard to beat painting outdoors on the coast. Even in winter on a fine day, it can be a pleasant way to paint. Most of my own paintings are done in the studio from sketches, but I do the occasional alfresco work as it can convey a marvellous sense of freedom, movement and spontaneity.

Painting outside, does, however, incur a number of problems. Working on a full painting, and especially if you are using an easel, means you are fair game to those who like to watch artists at work. Many will engage you in conversation and things can become distracting and inhibiting. If you are new to this it would be best just to sketch out of doors first, as you can then make yourself less conspicuous with just a pad and pencil, gradually working in a bolder way as you learn how to cope with distractions. Position yourself so that it is difficult for onlookers to interfere: halfway down a cliff can be most efficacious in this respect, but a little hazardous at times! You could surround yourself with so much paraphernalia that it becomes something of an assault course to reach you; a large hat also helps to isolate you to a degree. If you still find working outside too daunting consider joining a group or course that paints alfresco. Wrap up well – it is easier to remove three pullovers than to sit shivering for two hours.

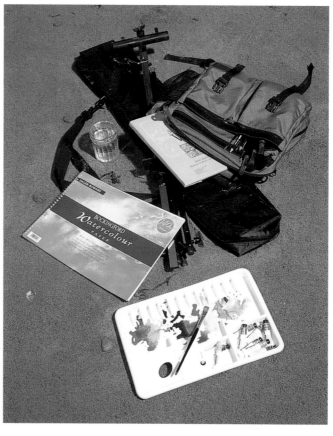

◁ Outdoor painting kit

For watercolour painting out of doors the bag holds a pad or block of watercolour paper, brushes, pencils, water container, clips and a palette. Also shown is a folding easel with its container.

▽ David Bellamy working outdoors

Here I am painting icebergs using a simple watercolour set in temperatures that are just above freezing.

BEGIN WITH A SKETCH

Beginning with a sketch makes sense, as it helps to position your focal point and main features, giving you an opportunity to work out the composition before committing yourself to the full painting. It will also help you to simplify the scene, to decide what to include or leave out, and if any feature needs to be

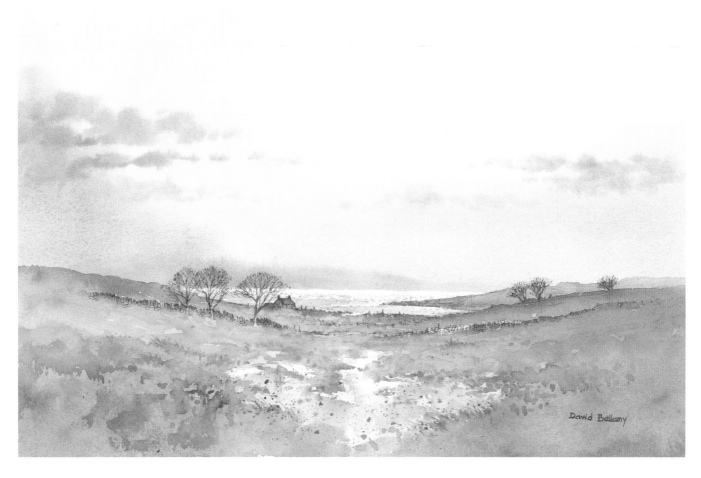

Evening, Galway Bay, Ireland
watercolour
20 x 32 cm (8 x 12½ in)

In order to keep the warm tinge to this painting a lot of Cadmium Orange has been used both in the sky mixtures and splashed around the foreground like donkey droppings. The darker clouds were inserted wet-into-wet during the early stages. There is some detail in the walls, which conveniently break down in the centre to allow the eye to follow through to the focal point, and some toothbrush spatter has been added to the foreground.

moved or altered in some way. It need only be a brief sketch, but can be further developed while washes are drying or during a coffee break when painting in oils or pastels. You can also make studies of elements within the scene. If you have to leave before finishing the painting consider which aspects of the subject you feel are most important to capture to enable you to complete the work at home. These can be sketched quickly so that you have a decent reference to work from later. Interesting figures should be included in your sketches.

THE UNFINISHED PAINTING

Many things seem to contrive to prevent us from completing a painting, and it is more sensible to accept that you cannot attempt to finish it than to rush the painting and ruin the whole for the sake of a passage. Work methodically and unhurried on the more important areas. Where features are repetitive, such as many similar windows, then render one in detail and simply outline the rest. Figures and boats, for example, can be included from various sketches when you finish the painting at home.

RECESSION

Chapter 7 touched briefly on depth, or recession, so let us now look at this more fully. There are a number of vital ingredients that will achieve a strong sense of depth in a painting: strength of tone, colour temperature, amount of detail and the relative size of objects within the composition.

When out painting or sketching look at the scene with a view to working out how both distance and atmosphere create depth. Note how tones lighten as they recede, how colours cool in the distance and how detail strengthens as objects approach. Note that while warm colours come forward it is also possible to see distant objects such as a cliff face glowing red in a sunset – in that case you need strong detail and tone in the foreground to counteract the colours. Dark distant objects can be neutralized by warm colours, strong detail and even darker tones closer to the viewer.

Make notes on your observations in your sketchbook or notebook. Observation is something you can do while you have a few moments to spare, with or without a sketchbook. Screw your eyes up into a half-closed position to read the scene for tonal relationships and atmosphere.

WATERCOLOUR OUTSIDE

Watercolour is a superb alfresco medium. I tend to use half-pans outdoors, as they are more convenient, though tubes are useful if you are working on a large scale. Whether you use stretched paper, watercolour pads or blocks, your paper should be well protected from knocks or being touched by skin coated with sun cream. If you work with the pad or board on your knee then a rolled towel or similar under the board

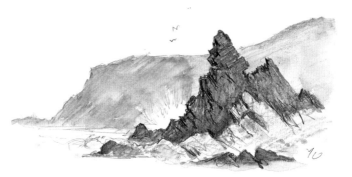

◊ Caerfai Bay

This sketch made in water-soluble pencil demonstrates how dark tone in the foreground suggests depth. The effect is further accentuated by the inclusion of strong rock detail close by, with none on the distant cliff.

◊ Devon Bay

A hint of warm colours in the foreground helps to create recession against distant cool colours in this watercolour and watercolour pencil sketch. Had I used a grey watercolour pencil to suggest detail on the far cliff it would have been even better.

▽ St Bride's

In this original pencil sketch the tonal recession has been engineered so that the strongest tones are on the focal point in the middle distance, rather than the actual foreground. If this does not work in a scene you can always darken the foreground accordingly. Note how the offshore rocks have been treated when I ran out of paper on the left. I have also deliberately darkened the water slightly around the splash to make it stand out.

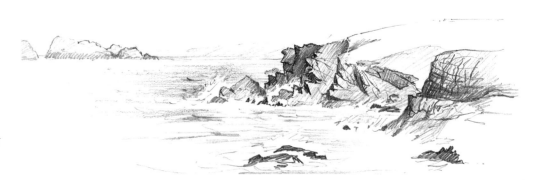

will give it a suitable slope to cope with the washes. An umbrella can provide shade as well as preventing a downpour ruining your work. Take a jam jar full of clips and elastic bands to hold down your paper, as even the slightest breeze can cause havoc.

Washes may dry quickly out of doors, so use plenty of water. Rough paper generally takes slightly longer to dry. A tiny drop of glycerine or slow-drying agent in the water will slow down the drying process. Take along plenty of water as passing dogs and ducks can quickly exhaust your supply.

ALFRESCO OIL PAINTING

Oil painting presents the most practical difficulties out of doors, and needs careful preparation. Once you have established your working methods, however, there should be little problem. While you may wish to take along a full oil-painting kit, it is best to restrict the amount of gear you use until you have some

experience. A few colours in a small box – consider buying a pochade box, which contains everything you need for working outside in oils – a selection of brushes, rags and supports, and an easel should be enough to start you off. I use a Daler-Rowney Westminster easel, as it is metal, strong and can easily be anchored down with ropes and tent pegs in a force ten gale. Lightweight easels might sound an attractive option, but they can blow around like a moth in a sandstorm.

You need a system for transporting canvases and panels, otherwise your good work will be inadvertently smudged. Some outdoor oil boxes incorporate their own sliding systems for securing supports without the faces actually touching anything. On beaches sand can become quite a pest when blown onto a wet oil surface and, of course, you need to keep your materials clear of the sand. Again, spending a few minutes observing and making a preliminary sketch will alert you to any likely hazards.

TAKING PASTELS OUTSIDE

Many balk at taking pastels outdoors because of the mess, but if you take along a pack of wet wipes, rags and maybe a small towel you should manage easily. Carrying washing facilities in the car is another idea. I always have wet wipes beside my pastels anyway, in case I have to answer the telephone or handle something. Pastels in transit should be well protected: ensure they do not rub laterally and have a stout folder or pad cover around them. It is wise to carry a variety of pastel papers and colours for flexibility, and bulldog clips are worth their weight in gold. Beware of lightweight boxes that can be blown over a cliff with your complete set of pastels.

◁ **Cottage at Abereiddi**
wash and line
10 x 18 cm (4 x 7 in)

This attractive pink cottage is attached to other buildings, which complicate the composition a little, so I have faded it out on the left. A phalanx of hollyhocks might have worked equally well. Pen and wash is highly effective on buildings.

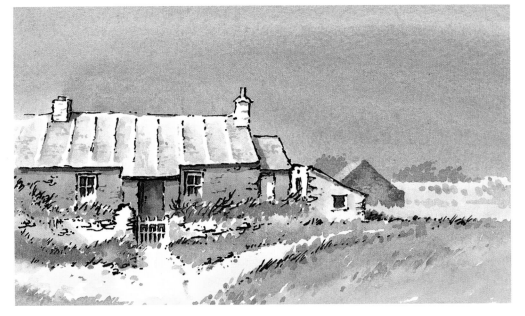

demonstration: Bosham

Wash and line 10 x 23 cm (4 x 9 in)

This simple watercolour sketch was carried out beside the car with the tide rising. Nearby notices warned of cars getting flooded by tides, so as I painted and photographed the sketch I had to watch the tide to know when to run. This is the frenetic result.

⬆ **Stage 1**

I began, optimistically without a preliminary drawing, hoping for a fair wind and someone to hold back the tide. I mixed a large amount of French Ultramarine and Cadmium Red in one of the palette wells and applied this with a No. 10 sable horizontally across the paper, trying at the bottom to dodge around the white sail that was a distinctive feature of the scene. Had I more time I would have placed this in a different position, but speed was of the utmost.

⬆ **Stage 2**

This second stage simply involved drawing in the details with a black-ink brush-pen for speed. This was accomplished without mishap, but pressure was mounting.

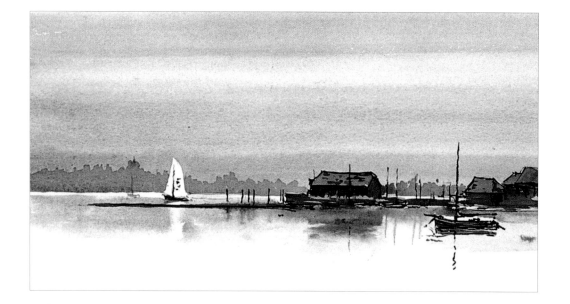

◁ **Stage 3**

Things become a little hazy at this point, as there was no way I could take notes in addition to paint, etc. Three balls in the air at a time is quite sufficient. Distant trees formed the background and these were simply painted in a deeper shade of the sky colour. Again I managed to miss the sail. The buildings became a mixture of Light Red and Cadmium Red. Finally I added the foreground water, pulling out the reflection of the sail with a damp brush. I had made it with a few minutes to spare. Sometimes under pressure the best, most unfiddled-with work is produced.

exercise 6: Capturing a sense of depth

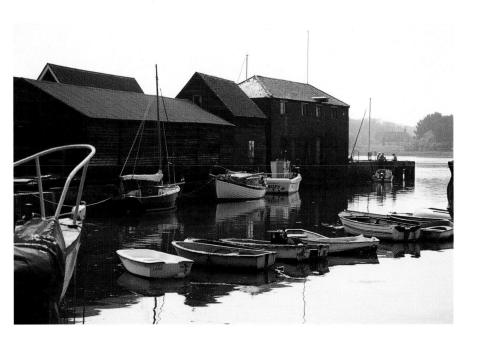

1 Find a subject of your choosing that has features in the distance, and carry out a monochrome sketch – water-soluble graphite pencils are ideal for this. Concentrate on achieving a sense of depth using tone and detail.

2 Try a similar subject to Exercise 1 above, but this time work in colour and use mainly warm and cool colours to achieve the feeling of depth.

3 The photograph shows Dell Quay near Chichester. Try a painting of the scene, but reduce the number of boats. I have done a watercolour of it on page 122, but use a medium of your choice.

◁ **Dell Quay, Chichester**　　　▽ **Freshwater West**

9 BEACH COMBING

In the right conditions, there is something infinitely pleasurable about working on a beach. Beaches vary considerably, from tiny coves hemmed in on three sides by intimidating cliffs, to wide open spaces invoking a wonderful sense of freedom. Before visiting a beach I consult the tide tables, and this is particularly important with long beaches or interlinked ones where it is easy to become cut off by an incoming tide. Artists are especially vulnerable to this, as we so readily become wrapped up in our painting that the first warning one often gets with the tide is when it is lapping gently over the brand new box of paints.

When I locate a subject I look for rock pools, interesting rocks and wet areas of sand to provide an interesting foreground. Seek out rivulets running down the beach, for these are extremely effective lead-in devices and, of course, in a painting can be moved to conform to your needs. Sand tends to move anyway, and some beaches experience considerable shifts of sand areas, the level changing by several feet over a period. At Malindi, in Kenya, I once walked along the beach when it suddenly got up and began walking into the sea – then I realized that I had scared thousands of small crabs!

PAINTING SAND

Large areas of sand can be a little boring, but you can break them up in several ways. First, look at the

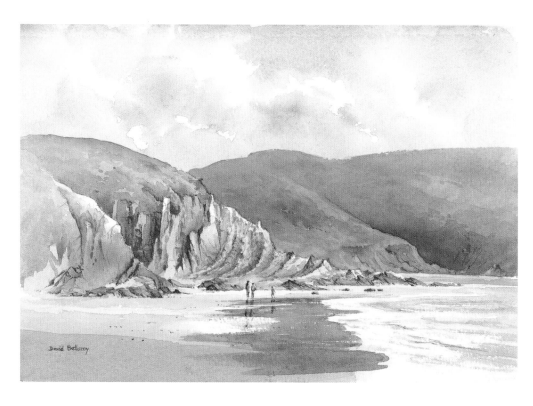

⇧ **Swanlake Bay, Pembrokeshire**
watercolour
18 x 27 cm (7 x 10½ in)

This is a small watercolour on 650 gsm (300 lb) Waterford rough paper. The background cliff structures fold into amazing contortions, with warm and cool colours present. The figures act as a focal point, yet not so strong as to detract from the cliffs.

colours and tones. Usually there is some variation that can be emphasized. Consider moving your viewpoint to where a cast shadow or patch of wet sand punctuates the beach. Wet sand also provides reflections to give added interest. Even small white gulls can trigger fascinating reflections as they stand in a wet patch or when flying over it. With birds in flight you might feel happiest capturing them on film, rather than in a sketch, but do observe them carefully as this will help your understanding. Clumps of

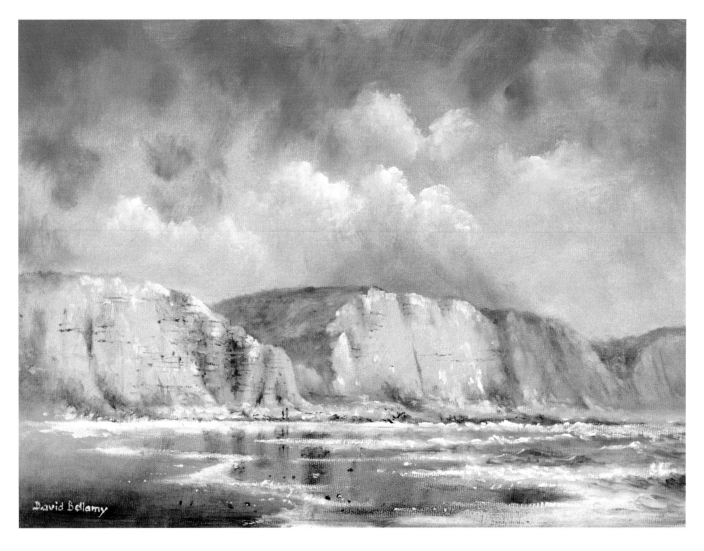

Cliffs near Southerndown
oil on canvas
25 x 36 cm (10 x 14 in)

I began by rubbing Yellow Ochre all over the painting with a rag, then painted in the sky with French Ultramarine and Titanium White. To warm up the lower portions I added weak Alizarin Crimson. The cliffs were worked mainly in Yellow Ochre and Naples Yellow, suggesting detail with Burnt Sienna and Cadmium Red. For the sea I returned to French Ultramarine and Titanium White, then tidied up the painting around the wet beach.

seaweed and rocks also work well in this context, and a rock in its own little pool can provide a focal point. Groups of figures are another possibility, and if placed in the middle distance do not overwhelm the scenery. Sometimes even beach detritus can be included, as this is often colourful. Occasional small rocks and pebbles can provide further interest, but do try to keep some of the beach area uncluttered.

ROCK POOLS

Rock pools make superb foregrounds to more distant features such as caves, arches, pinnacles, cliffs, and so on. In the middle distance pools can add a bit of sparkle or interest to a scene. Rock pools are usually crystal clear, and so with foreground pools you will most likely need to suggest some detail beneath the surface. Whichever medium you are using it is best to

paint in the underwater detail first – not too strongly – and then apply a light-toned glaze over it so that the detail is still visible through the glaze. When using both oils and watercolours you will need, however, to allow the detail to dry before applying the glaze. If you are including underwater detail it is simpler to omit any reflections.

REFLECTIONS

While you can hint at reflections in the sea by suggesting tone or colour in places, sea movement tends to inhibit any great interest. On beaches, however, reflections can be a more prominent part of the subject. Bright colours are particularly effective in reflections on wet sand so you may wish to intensify this brightness to make more of the feature. Observe how the closer the reflection is to the object being reflected, the more accurate is that part. It helps to break up reflections with strips of dry sand, slivers of light, strands of seaweed, rocks, ropes or whatever seems appropriate. Suggested reflections in small streams on a beach are also extremely evocative, but try not to strive for a mirror-quality finish.

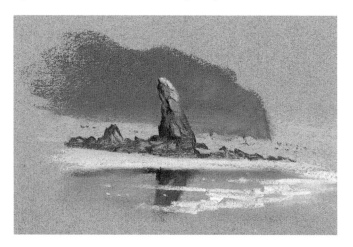

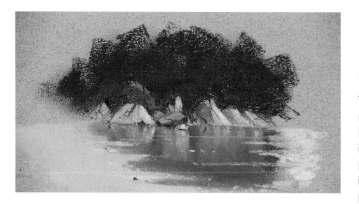

⬆ **Short beach reflections**

With smaller rocks it is easy enough to simply suggest short reflections, with or without the white streak. There is nothing to stop you using short reflections for the larger rocks – the secret is to keep them all consistent.

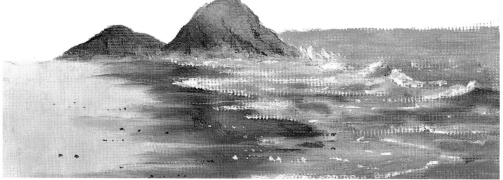

◁ **Long beach reflections**

In this pastel sketch a huge pillar of rock casts a long reflection into the wet beach, so it is useful to break the reflection up with a streak of white surf. Spits of dry sand do an equally good job.

▽**The waterline**

This oil sketch illustrates how ragged the waterline can become, which, of course, adds interest. You can shape it in a painting to conform to your own ideas for the composition. In places it is hard-edged, in others the divide is completely lost. Watch out also for any useful reflections and try to break up large sandy areas with shadow, wet parts, seaweed, rocks, people, or whatever.

THE WATERLINE

Sometimes the meeting of beach and sea is etched in strong contrast between dark wet sand and foaming white surf, and at other times it is almost impossible to distinguish. Take advantage of this by varying the edge of the water so that it is well defined in places and lost in others. As with so much to do with the sea, it pays to stand and simply observe for a while before committing yourself to paper. The water's edge can be interrupted effectively with rocks, seaweed,

figures or boats, even sandcastles. Where rocks meet the sea, splashes of white water can be introduced in a more boisterous surf.

PEBBLE BEACHES

Pebble beaches can appear overwhelming to the artist, with millions of multi-coloured pebbles of varying sizes spread out before you. When rendered in a more limited way, though, pebbly beaches make attractive compositions; so how do we simplify this mass of detail in front of us? Many of the offending pebbles can be hidden behind a large rock or two. Try breaking them up with pools of water, beach streams, seaweed or patches of sand. Another device is to lay a cast shadow over them; this will not eliminate them but it will soften the effect on the eye of the viewer.

Pebble beach vignette

Pebbles on a beach can be attractive, but a little overwhelming for the artist at times. Try to reduce the amount, suggest more sand, large rocks or seaweed, and consider vignetting the pebbles as in this watercolour sketch, where I have tailed them off in number as they approach the viewer.

Beach streams

Use streams and channels of water on beaches to lead you up to the focal point – in this watercolour sketch it is a figure. Consider varying the streams with tonal reflections caused by dark or light skies, rocks, cliffs and so on, and note how many break up into multi-channels.

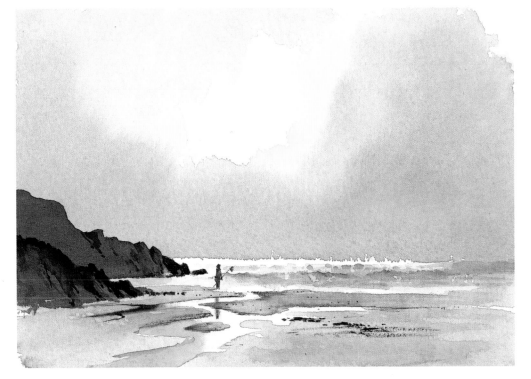

All these methods of course, can be combined in one painting, but beware of making the foreground too complicated. Abstraction is another possibility, covered on page 87.

One technique that works effectively with pebbles is the vignette. This involves leaving out most of the detail, but inserting some pebbles in strong detail, others merely suggested, and then fading them out, or reducing them perhaps to a linear 'tail', which acts as a lead-in, as they approach the foreground. Another option is to fade the pebbles out evenly along the edges as found in many Victorian photographs.

FIGURES ON THE BEACH

A single figure or couple on the beach can provide a prominent point of interest, as the eye will immediately be drawn to them, especially when accompanied with a splash of colour. Such figures

demonstration: Ebb Tide, Westdale Bay

pastel 18 x 29 cm (7 x 11½ in)

Westdale Bay is a lovely, sandy beach with stunning wine-red rocks. I decided to use Canson light-grey paper in this instance.

◁ Stage 1

With the large sharp rock as the centre of interest, I decided to include a sweeping channel of water in the foreground to lead up to it. After drawing the outline with a pastel pencil I began working on the sky with a range of colours, including Yellow Ochre, Cobalt Blue, Mauve, Crimson Lake, Silver White and two shades of Blue Grey. Then, with Indian Red 4, I painted in the rocks. On the sea I used the two Blue Greys.

▷ Stage 2

Here I continued work on the rocks, using Madder Brown 8 for the darker areas, then rubbed Silver White into their wet bottoms silvering in the sun. Cool Grey 6 and 4 helped to define the dark sides. For the closest band of sea I applied Purple Grey 2, then Naples Yellow 1 with Crimson Lake 1 over the foreground sand.

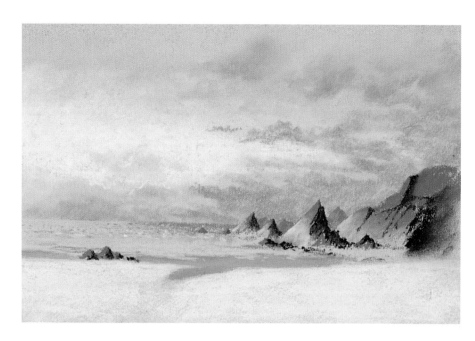

Stage 3

This short stage simply involved adding darker parts to some of the rocks and the white splashes in the sea.

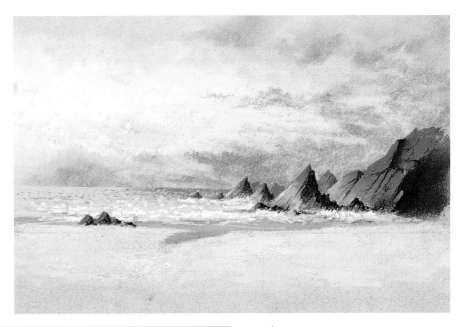

Stage 4

Now I increased the rock population with a few minor additions, then drew in fracture lines with a dark pastel pencil. Next came the foreground channel, which neatly broke up the beach. I added white to the right bank to suggest sunlight catching the gently sloping sides. The final touch was to insert the reflection of the small rock in the channel.

David Bellamy

can create a striking reflection in wet sand, perhaps in an area devoid of any other detail, so take care in positioning them. Single figures on an otherwise empty beach can look lonely, which is fine if that is what you wish to achieve, but beware of scattering them all over the beach area.

Seaside groupings of figures can make for lively and colourful focal points. It is easy to sit amidst a crowded beach and make small drawings of people and groups without attracting attention, perhaps keeping your sketchbook inside a magazine! A large sunshade or hat also isolates you from prying eyes. Draw people in action or reading, relaxing, building sandcastles, surfing or the many activities that happen. In such a scene, sunlight is important, so try to catch the sense of a sunny day. Use one figure or grouping as a focal point and reduce others to a supporting role, or subdued in the cliff shadows perhaps. Deck chairs and windbreaks not only add colour, but can break up too much figure detail.

▽ **Beach near Llangrannog, Ceredigion**
pastel
23 x 32 cm (9 x 12 1/2 in)

I worked on a mid-grey Canson paper. The sky was a combination of Yellow Ochre, Naples Yellow and White. I used mid and dark greys on the cliffs and rocks, plus some greens and ochres in the middle distance, with a warmer Olive Green on the closest cliff. I then overlaid the cliffs with a light grey pastel to tone down the detail and strength, before working on the sea and beach details.

BEACH COMPOSITIONS

Large areas of sand can be useful as quiet passages within the overall scheme, but, as with general landscapes, you do need a fairly strong focal point. This can be a prominent rock, a rock pool, part of a cliff, cave, arch, wave splash or figure. Often, though, you will need to move around until that small, but well-formed, rock can be reflected in its pool and used in the foreground of a beach devoid of much interest. There have been times when I have removed my shoes, rolled up my trousers and waded into the surf to get such an angle on a potential focal point – often to find it did not work! Once you have established a focal point try to find a lead-in such as strands of seaweed pointing at the centre of interest, or perhaps the curving line of the surf edge.

Beaches beneath high cliffs are usually at their best during certain times of day when the sun is in the right position, so it might be better to return another day at a different time. Trying to visualize how the painting might appear in different lighting is a powerful tool for the creative artist. Will evening or early morning light strike part of the cliffs? If so, that might be the optimum time to paint, especially if you value peace and quiet. The light is a strong ingredient in setting the composition, so keep it in mind as you plan your picture. Move around. Go into the palm trees and study the beach and sea broken up by the trunks. Look at it from a new angle.

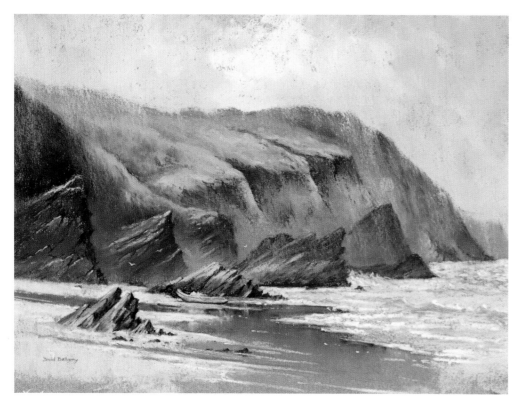

1 Try sketching some general beach scenes to start with, especially those without much close detail. You might like to try a loose approach with charcoal or conté-crayon, for example. Stand away from the surf and render it without too much working.

2 As a contrast to the above, work on a number of pencil or ink studies of beach features such as pebbles, rocks, seaweed, pools, cliffs and the water's edge. Consider bits of netting, old buoys, driftwood and other objects washed up by the tide, as even these can make excellent centres of interest or supporting features. Try to include reflections at some stage.

3 Do quick sketches of figures walking, bathing, surfing and in action from a range of distances, and more considered ones of people relaxing, sitting, sunbathing, fishing, reading or whatever. Relate the figures to their environment if possible, such as deck chairs, rocks, surf and reflections.

4 Do a painting of Three Cliffs Bay from the photograph and try to bring out the sense of sunshine. My pastel of the scene can be found on page 123.

 Beach figures

▽ **Three Cliffs Bay, Gower**

▽ **Surfers**

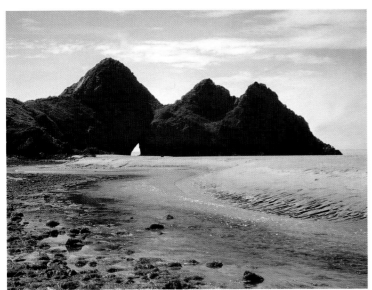

▽ **Different approaches to gulls**

10 PAINTING THE SEA

Down the centuries the sea has provided inspiration for artists at all levels. Anyone can paint the sea: we simply need to define our own limits and work within them, every so often pushing ourselves a little further. The sea provides an ever-changing variety of subject material full of life and movement. This constant movement presents a considerable challenge to the artist working in any medium, sadly putting off many who wish to tackle the sea. On one occasion while engrossed in sketching wild waves with a water-soluble pencil I was engulfed up to chest height by a huge wave, and, after clinging on to a rock, found that sketch had been much improved by the event. Here we look at ways of reducing the problems and creating interesting waves and surf, ranging from gross simplification to detailed observation and rendering.

To begin with, a much simplified sea will certainly help your early efforts. This can be achieved by standing back, away from the sea, and rendering only the main features of the water. It is important not only to retain the white highlights, but to add some in if the sea happens to be almost flat calm. What looks fine in reality will look dead in a painting of the sea without this punctuation of white. In watercolour it can be difficult to retain much of the white paper, so resort to masking fluid if you wish. You may have to darken the water a little to make the white stand out. White splashes next to dark rocks can look particularly effective.

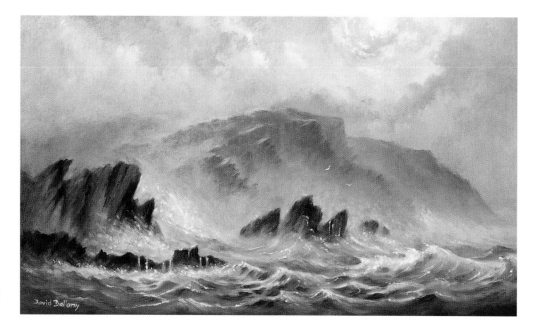

A BASIC APPROACH TO PAINTING THE SEA

We need to give a sense of distance to the sea, so in this respect it helps to divide the visible sea area into three distinct parts, working from the top (more distant) to the bottom, or foreground. The first horizontal band at the top of the sea need only be a narrow strip that is best kept mainly devoid of detail. Sometimes a flat passage of colour will suffice, or a dry-brush dragged across the area. Another way is to flick in a few weak strokes with brush or pastel onto the painted strip. The second (closer or middle distance) area needs a little more detail suggesting the tops of the waves and preferably including white

⬆ **Cliffs near Rhoscolyn, Anglesey**
oil on canvas panel
30 x 39 cm (12 x 15½ in)

I wanted to portray a rough sea with wild background cliffs draped in a misty atmosphere. This called for vigorous brushstrokes for sea, spray and mist, soft against the rugged anvils that rise out of the water.

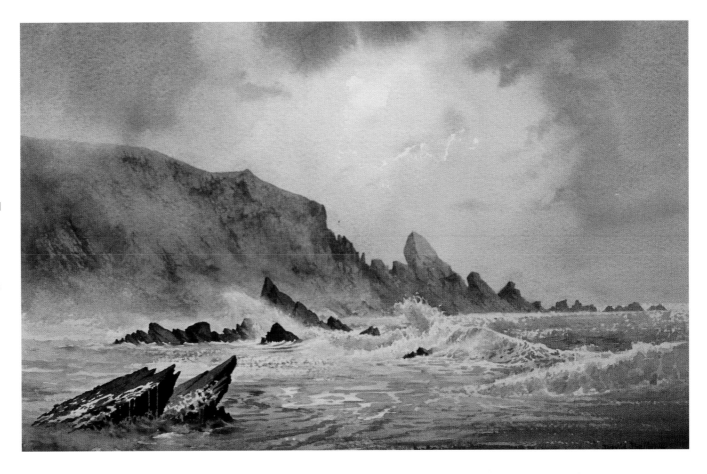

Westdale Bay
watercolour
25 x 34 cm (10 x 13½ in)

Large areas of surf are not easy to render, especially as they tend to overwork the foreground. Here I have introduced reflected colours into the surf to add interest and positioned strong rock shapes to counter the mass of foaming water.

Perspective on the sea

To achieve a sense of depth on a flat surface split it into three different zones.

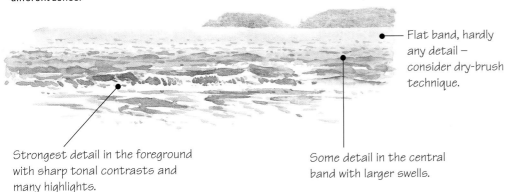

Flat band, hardly any detail – consider dry-brush technique.

Some detail in the central band with larger swells.

Strongest detail in the foreground with sharp tonal contrasts and many highlights.

highlights and perhaps a little more colour. Merging the furthest and middle bands almost imperceptibly gives an improved transition between the two.

The closest horizontal band should show the breaking wave or surf, sometimes both. Where this band meets the middle one is a critical point and, while it needs strong contrast to emphasize the crest of a wave, for example, there also should be quieter conjunctions. The water should be more detailed to include most of the white highlights. A stronger injection of colour here always pays dividends. Surf crashing can exert an excellent focal point.

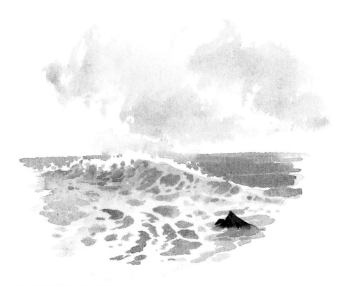

PAINTING SURF

If you have an aversion to painting waves you can still paint the sea and shoreline without having to render complicated wave structures. In between each wave comes a quieter moment, as though the sea is taking a rest. During these moments the water is generally easier to paint. By moving further away from the shoreline, up the beach or even beyond it, the intricately woven details of the surf recede and you can concentrate on the main forms. I would strongly recommend this approach to all newcomers to painting the sea, because it is impossible to absorb everything straightaway. When you wish to work closer, break the scene down into manageable proportions by making studies of different parts of the surf. Note how the rising swells of incoming waves blend into the more frothy surf, the froth broken up by patches and streaks of darker water. As well as the shapes, observe colours.

Water splashing against and spilling over rocks provides a wonderful combination of action with hard

◁ **Surf patterns**
watercolour

Try to simplify the amount of surf detail as much as possible, as it can becoming overpowering. Cast shadows and rocks are effective in breaking up large areas of surf.

⇨ **Breaking wave**
watercolour

It pays to observe waves carefully to see how they break. Normally the wave's character varies along its length. In this view the wave is breaking as it is just about to hit the rocks. The higher the wave the lighter and more translucent the wave becomes. Adding colour greatly helps to show up the wave, but beware of making it look too twee. Try to alternate hard and soft edges. Note, in particular, the curves, highlights and top edges of the wave.

and soft edges. This action can become the centre of interest, or remain as a minor feature to balance another part of the composition. It can be an extremely useful way of breaking up a line of sea-girt rocks or cliffs. Keep your splashes and spills fairly simple, though, as too much prominent detail can detract from the effect.

PAINTING WAVES

Waves are amongst the most difficult of features to portray in a painting because of their constant movement and curving shapes. Only close observation, combined with deliberate sketching studies, will yield effective wave portraits.

Get into the sea, or as close as possible. On a hot summer's day I have had course members paddle in the sea to get closer to waves. Watch waves for some time without attempting to draw or paint them. Note how they appear before they break, then observe carefully as they begin to break, and each stage following until they merge into the surf. Waves often come in at an angle to the shore, rarely absolutely

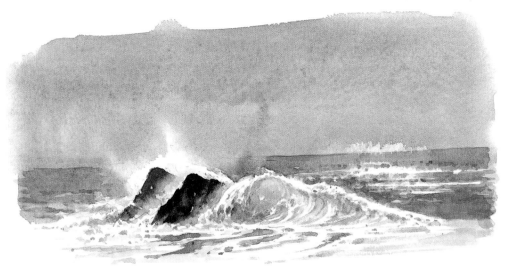

parallel, so the character of the wave varies along its length. Adopt a considered approach to wave study: first observe how it begins to break. Watch many waves just at that point and when you feel ready, draw in that detail. Pencil is as good as any medium at this stage. When you have drawn a number of studies in this way, shift your observation further along the wave to the next point where the wave is curving over before crashing down. Make studies of this part, and continue in this manner until you have achieved a complete wave.

So far you have only been studying the shape of the wave. Now change your focus to concentrate on the various colours and tones, picking out the stronger ones and noting where they occur. Colour is important in defining a wave, but do not feel that every wave has an obligatory translucent glow near the crest. Naturally this depends on the angle and quality of light and the effect can so often be overdone. You may also find coloured pencils or watercolour pencils easier to control in these situations. Photographs help, but beware as sea water is corrosive to your camera.

INTERLINKING AREAS OF DIFFERENT WATER CHARACTERISTICS

Observe carefully where areas of different water characteristics meet: waves into surf, whirlpools, water surging over and around rocks, or crashing down like a waterfall. While chopping the problem into manageable chunks helps, you still need to keep an eye on the overall scheme. In watercolour this can be daunting, so pick a fairly self-contained area of water and paint the overall light colour first, reserving whites. Then, when working on stronger tones with

more detail, allow a generous overlap at the edge of the area to be joined. You will need to fade it out a little so that when you come to paint on the adjacent part the 'join' will not show. Pastels and oils need no such forethought. Linking in this way can be challenging when a powerful surge of water is thrusting between rocks and creating strongly contrasting characteristics.

CAPTURING A SENSE OF MOVEMENT

Painting effective seascapes demands a sense of energy and movement, with waves or surf punctuated by prominent white spills, foam and splashes. Motion can be emphasized by vigorous brush or pastel strokes. Introducing strong diagonals, whether in rock structures or the water, will inject dynamism into your work. Waves, crashing surf, or wind-torn spindrift carried off the crest of a wave, with a diagonal bias will certainly suggest movement, especially when done in conjunction with vessels heeling over at an angle and seabirds caught tossed on their side. In storms and violent seas the water froths up into a wild whiteness, so you need to create a preponderance of light tones. On a calm day you will need to work harder at creating movement, using imagination or memory.

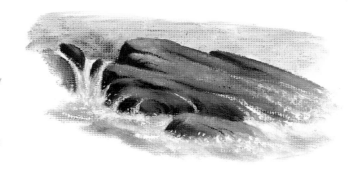

◁ **Wave spill**
oil on canvas

This is slightly easier to render than the actual waves, but watch for the nuances of tone and colour, such as shadow areas, most visible on a sunny day. Try not to include too much wavespill detail, but make the more distant ones less contrasting and more subdued.

demonstration: Wave spill
Watercolour 13 x 30 cm (5 x 12 in)

This small elongated watercolour is really about one piece of rock with water spilling over it. It took much scrambling and a little wading to reach this point, so having got there I was determined to make something of the scene.

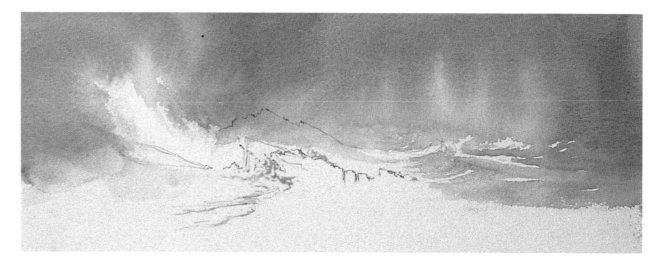

⬆ **Stage 1**

After applying masking fluid to the surf, spills and gulls I unleashed a wash of French Ultramarine and Burnt Umber across the sky, with some Naples Yellow to the right of centre. Then I put a mix of French Ultramarine and Yellow Ochre across the sea.

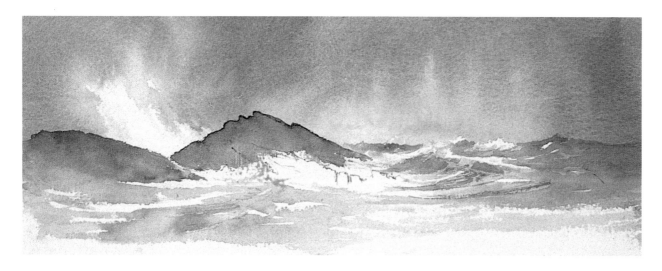

◊ **Stage 2**

Again, using the sky wash a little stronger, I applied it to the rocks, immediately pushing Yellow Ochre into the wet area. Sea details followed, mainly using French Ultramarine.

Stage 3

This stage was spent working on strengthening the rocks.

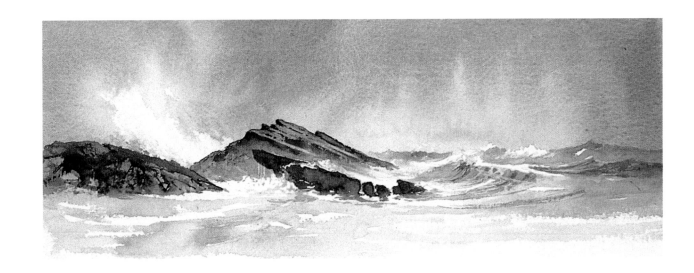

Stage 4

After re-wetting the sky, I re-stated it with a darker version of the original mixture, then worked on the wave and surf. For this I used the French Ultramarine and Burnt Umber mix, pushing in some Yellow Ochre in places. Finally I removed the masking fluid and tidied up the rock and spills.

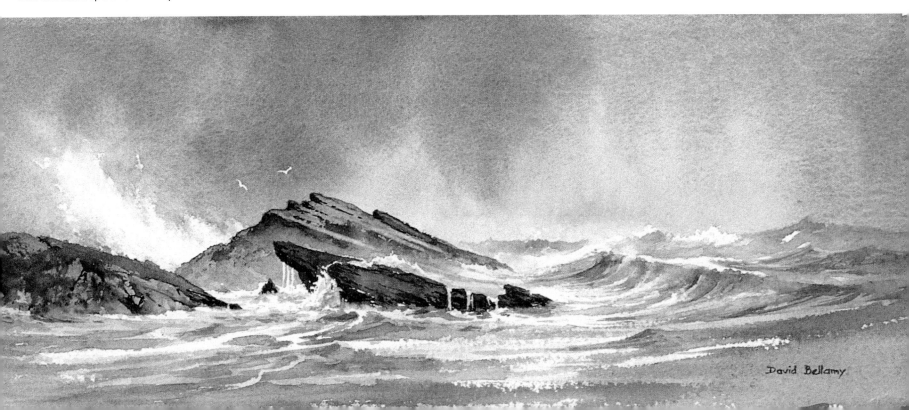

David Bellamy

⬦ **Wave splash**

Whatever medium you use try to suggest a little tonal definition within the splash, but do not overdo it. With pastel, as in this case, sweep the stick across in places to indicate the force behind the splash.

COMPOSITION IN SEA PAINTINGS

Nowhere is the old adage 'never place your horizon line halfway down the composition' more appropriate than in paintings of the sea. However, there are exceptions to every rule and even that dangerous approach may be successfully employed in certain situations. It is normally best to keep the horizon line around one third of the way from the bottom or top. If a wave is to be the focal point then only impart strong detail and contrast to one part of it, not the whole length. Too much excitement can turn a painting into a caricature. Losing the horizon in places can be effective, or employing counter-change where part of the sea is light with a darker sky above and another part is dark with a lighter sky above. This, of course, should correspond with the lighting arrangement of the whole painting.

The amount of sea that can be observed can be vast, especially from a cliff top. In this case any horizontal bands of cloud shadow will add variety to the sea surface, or can highlight a focal point. Any such bands can be broken up with a more vertical feature such as a headland, rock, ship, gull, or whatever you can find. This is also true of the horizon line, which can at times appear intrusive.

▽ **Beaching in the Rough**
watercolour
23 x 32 cm (9 x 12½ in)

This scene shows a fishing boat about to beach through rather interesting surf. In places I used masking fluid on the boat and the white splash beneath the prow, but the main splash itself was tackled without any such assistance, as I wanted to keep the edges soft. The orange oilskins and warm-coloured pebbles offer a change of temperature and colour to a chiefly drab scene.

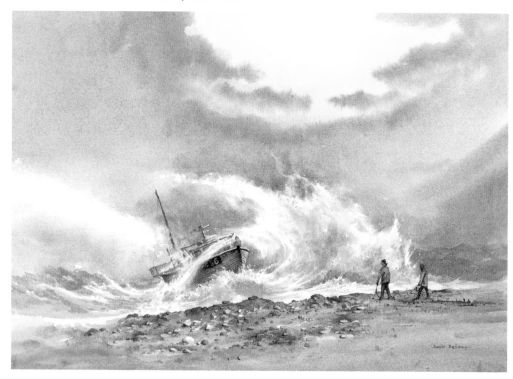

exercise 8: Painting the sea

1 If you are new to sketching or painting the sea find a suitable shoreline and carry out a number of sketches some distance from the edge of the water. Do not attempt too much detail; simply aim for a general impression of the surf and the adjacent part of the beach. Once you feel more confident go in closer to capture more detail, but beware of an incoming tide and every so often a larger wave that can come in and catch you by surprise.

2 Find a safe vantage point near some interesting-looking rocks on a blustery day when waves are splashing over the rocks. Watch for some time, then attempt to capture the great splashes. While you may not wish to sketch a storm, my water-soluble pencil sketch of one off Little Castle Head will give you an idea on how to sketch fast-moving water on a windy day.

3 Go in closer and work on the waves, beginning with charcoal, pencil and water-soluble pencil, then bringing in some colour.

4 Have a go at a painting of Porthselau, playing down the background hill, but concentrating on the water. Should the beach be included? Try to inject a little reflected colour of the rock into the surf. Use whatever medium suits you. I have carried it out in oils and my painting is shown on page 123.

⬆ **Storm at Little Castle Point**

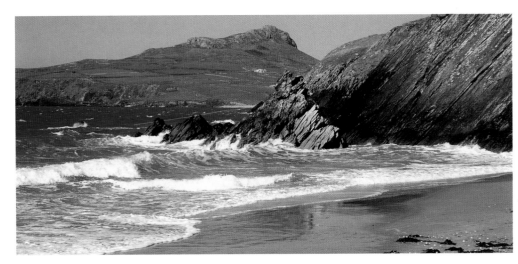

◁ **Porthselau, Pembrokeshire**

11 ROCKS & CLIFFS

Nothing excites my pencil more than the interaction of rocks and water, the one solid and dependable, the other fickle and transient. Rocks and cliffs are found in a variety of shapes, textures, colours and surface detail, their appearance greatly affected by the elements. Because of their reflective quality they are particularly susceptible to the nuances of light. Rocks are the foundation of the coastal landscape, one of the few elements with an individuality – some are like old friends, constant and ever willing to pose, whatever the weather.

Rock structures provide a sense of local character, which for the artist is an important ingredient in portraying a sense of place. The rounded slabs of Cornish granite are very different from the dramatic vertical bedding of the South Pembrokeshire limestone cliffs, for example. Softer rocks are eroded by sea action, smoothing them into rounded shapes. In contrast, harder, more resistant rocks form jagged anvils rising out of the sea. The bedding, fault lines and fracture lines should be carefully observed in order to put across the local character and lend authenticity to your work. Rocks can vary so much in character, not just from region to region, but even within the same cove.

PAINTING ROCKS AND CLIFFS IN FIVE STAGES

Rocks and cliffs are best tackled in distinct stages, and recognizing the importance in each stage will enhance your work as well as making rocks easier to render. Begin by lightly pencilling in the general shapes. Note the most distinctive features such as strong fault or fracture lines, the general angle of the strata, and any pinnacles, arches and caves.

Once you are happy with the position of each feature the second stage is to consider the colours. The colours of rocks are affected considerably by light and becoming wet. Colours in sea cliffs are

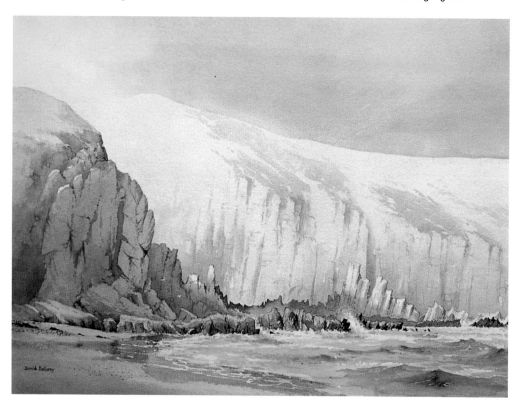

▽ **Evening Light, Presipe Bay, Pembrokeshire**
watercolour
25.5 x 51 cm (10 x 20 in)

Warm evening light on wine-red cliffs contrasts with the shadowy rocks and the closer cliff, the effect accentuated by stronger detail on the nearer features. The punctuations of white paper focus on the highlights.

◁ **Detail from Rock Arch**

I changed the background to the arch from dark to light and introduced figures to suggest a sense of scale. The large rocks at the bottom right have been lengthened and aimed at the arch rather like cannons to accentuate the focal point.

▷ **Rock Arch, Bullslaughter Bay**
watercolour
33 x 23 cm (13 x 9 in)

Bullslaughter Bay has many gems, most of which are quite challenging to the artist. This is no exception and I really had to think about the treatment beforehand, in order to reduce the overwhelming detail. So the upper central cliff gradually gets lost in the atmosphere; the left-hand cliff is virtually devoid of information; and much of the rounded boulders have been suggested rather than drawn in detail. The figures lend a sense of scale, but the actual arch behind was dark and dire, so I decided to set it alight with Cadmium Yellow and Yellow Ochre. Pink on the foreground boulders suggests a hint of light.

often layered or formed into distinctive patterns and tend to blend into each other. In watercolour it helps to have all the colours in pools of liquid wash ready to apply one after another. Allow them to run into each other and do not worry if their boundaries are not exactly as seen on the actual rock or cliff. Make sure they are dry before going on to stage three. This blending stage is less troublesome in oils and pastels!

The third stage concerns textures, but if there is little obvious texture showing, or you are some distance away, you may wish to skip this stage. In watercolour texture is best achieved by dragging an almost dry brush across the surface on its side – the rougher the surface, the more pronounced the texture. Sometimes I find it useful to add in other colours while this is wet. Texture in pastels can be rendered with the side of the pastel stick to a degree, but also by deft flicks using varied pressure. This method using flicks can be applied to a dry surface in watercolour or oils to suggest a pitted rock surface.

Stage four is the application of the lighter shadow areas and fracture lines. Watercolourists may have to separate these two functions if they overlap, in case the colours run. Pastellists will no doubt find pastel pencils helpful for the narrower fracture lines. When painting in oils I sometimes use a painting knife for this. Students often experience problems in painting fracture lines, many ending up like a phalanx of emaciated caterpillars climbing a cliff in synchronized harmony. Avoid this spectacle by varying shapes and angles, and also the gaps in between the fractures. Have the lines ending in shadow or strong textural areas, or fade them out rather than stopping abruptly.

In the final stage the darkest shadows are inserted. Beware of shadow patches all over the place: while

this phenomenon occurs regularly in nature it is necessary in a painting to lose the 'leopard-spot' effect of strong isolated tones, as this can become a major distraction. In addition, take care with edges: soften some of them off. Watch also for reflected light in the shadow areas, particularly if the rock is wet.

RENDERING CLIFF DETAIL

Large areas of cliff face need careful handling. Too much detail can overwhelm, and every painting needs quiet passages. So how do you tackle a cliff with striking detail all across its face? First, select the most exciting parts of cliff detail and draw them in. These should be fairly close to the focal point, or perhaps even the focal point itself. If the better aspects are some distance away from the centre of interest then it would probably benefit your scene by moving them closer. Once this has been established the remainder of the cliff can be painted. In places try colour variation in lieu of detail. This can be an extremely effective substitute. Suggesting shapes with slight tonal variation is a further possibility, or a weak indication of detail blended at the edges into an expanse of uncluttered cliff.

Other ways in which to reduce detail include the introduction of a misty spray at the base of cliffs, wisps of mist higher up or a suggestion of haze, or a handy cloud shadow dropped over an appropriate part of the cliff. Not only will this lose much detail for you, but it can subdue an area and hence highlight an adjacent feature at the same time. Where you have little happening in a picture it can be useful to paint in one or two seagulls. These can add a sense of scale, life, and at the same time counter-balance the more detailed passages.

▷ **Colour and strata on rocks**

Observe the colour and strata on the rocks. While these elements do not need an exact rendering, capturing them helps to give a sense of character and place to a scene, as in this small watercolour. It is also helpful to abut the complicated areas of cliff with quieter passages.

COMPOSITION OF ROCK AND CLIFF SCENES

Rocks and cliffs, whether part of a general scene or not can form the centre of interest in a painting. Large masses of rocks or cliff surface need a focal point at one of the more interesting points, emphasized in the usual manner with contrast, light, detail and colour.

Look for the more handsome rocks and render these without too much clutter around them, as that

△ **Texture on rock**

A little texture here and there works well, but too much can intrude. In this pastel the effect has been applied by stabbing with the pastel stick. In oils and watercolours you can use brushes in a similar way. Dragging the side of a brush across rough watercolour paper is especially effective.

Cliff shape

Look for the overall shapes of rocks, crags and cliffs, and be sparing with the vast intricacy that even a small rock exhibits, as in this oil sketch. Note the manner and direction that the light hits the subject. View the scene through half-closed eyes, which will help to reduce the elements to basics.

Fracture lines

Fracture lines can look notoriously bad if not done properly. In order to avoid the appearance of a slug-climbing race, have the fracture lines starting or ending in a dark hole, arch or shadow, or taper them to nothing, as in this watercolour. You can also lose them in a mass of strong texture if you wish.

Oystercatcher
watercolour

will diminish their effect. Combining rocks with crashing surf or wave spill exudes a dynamism and contrast that is hard to beat. By contrast, a hazy or misty background increases the sense of power of the centre of interest. Pinnacles, protruding rocks, arches and caves are more easily adapted as a focal point, and bringing in birds close by can assist the illusion. Alternatively, there may well be too much interest with endless cliff detail – in this case bring across cloud shadow or mist to make life simpler.

In any composition your viewpoint is critical and on the coast your viewing height might not be an obvious consideration. While you will not always have any choice, it is worth considering if a high or low position helps your composition. High viewpoints give more underwater detail and a higher horizon level out at sea, hence more sea is visible and generally the perspective a little more complicated. A low viewpoint normally provides easier perspective and greater drama, with far less sea showing. Natural

arches, figures and boats are notoriously difficult from above. Getting to a lower viewpoint has led to some interesting episodes for me – once while roping down a cliff the face gave way and I crashed to the bottom in a whirlwind of rocks, dust and debris. Cliffs definitely need care, as they do not always stay still!

ABSTRACTION OF ROCKS

A certain amount of abstraction can work well as part of a normal landscape painting, and this is true of rocks and cliffs as subject matter. The foreground especially lends itself to this approach. By clearly defining a few rocks or cliff structures, and then progressing into abstract shapes that emit a suggestion of rocks and varied colours a work can be considerably enhanced. Where there are repetitive shapes, a great mass of rock, or a need to simplify, abstracting can be a vast improvement on trying to render every rock and stone. If you can find examples of conglomerate, with its amazing kaleidoscopic array

demonstration: Pwllstrodur, Pembrokeshire

Oil on canvas panel 25 x 36 cm (10 x 14 in)

This wild spot on the North Pembrokeshire coast lends itself to Homeric struggles with the sea. It is often lashed by mountainous seas. In this demonstration in oils my aim was to suggest a vigorous sense of movement against the rocky anvils.

▷ **Stage 1**

The outline drawing was carried out with weak Lamp Black over a light grey base. In the sky my first struggle began with Naples Yellow plus Flake White, with a mixture of French Ultramarine and Alizarin Crimson above. The sea was suggested with Cobalt Blue and a touch of Cadmium Red. Part of the cliffs was rendered with Yellow Ochre and Naples Yellow and for further excitement I added a little Cadmium Orange. I then decided to re-state part of the outline.

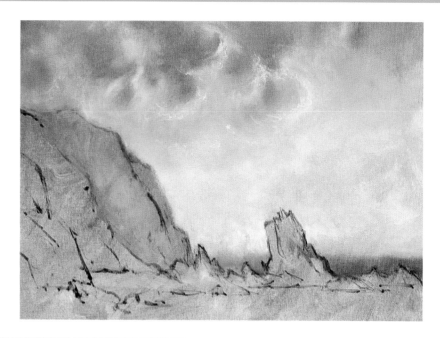

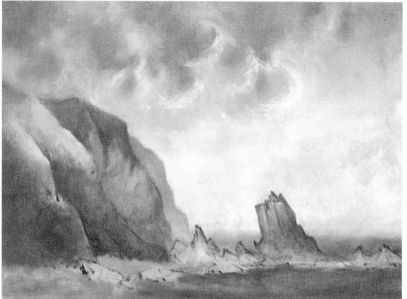

◁ **Stage 2**

This stage started quietly by plastering a little Naples Yellow on the cliff tops, then other colours lower down. The distant cliff was painted with Cadmium Red and French Ultramarine before I did further work on the middle cliff. Next came the rock pinnacle, the focal point, mainly in French Ultramarine with Yellow Ochre and Raw Umber added at the top and Cadmium Red at the bottom.

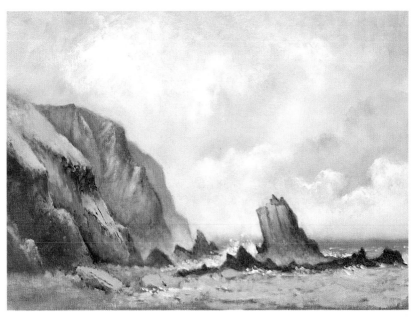

⇨ Stage 3

Unhappy with the sky, I decided to alter it, then lightened the left-hand cliffs. With a somewhat daring raid into the cliffs with a knife loaded with French Ultramarine and Titanium White, I stabbed on a splash of blue, a rogue colour amongst the ochres and umbers. These excesses are easily done in oils, and just as easily wiped off if they do not work! I then worked on the jagged rocks, white splashes and lightened the sea.

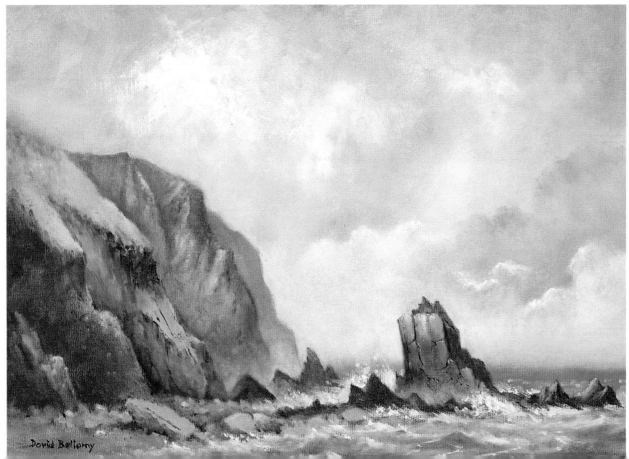

⇨ Stage 4

With a fine brush I applied detail to the pinnacle and then broke up the dark line of rocks below it with a splash of white. More detail was applied to the cliffs and shadow inserted under the left-hand rock. Further touches were finally added to the sea.

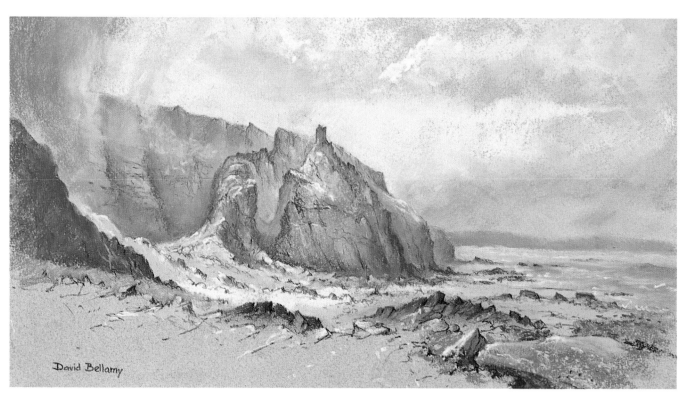

◁ **Cliffs at Druidston**
pastel
20 x 30 cm (8 x 12 in)

In this pastel I have deliberately left the warm grey Canson paper visible in the foreground – do not feel that you have to cover the whole paper when you are painting. Much of the cliff detail, particularly on the left, has been lost by introducing mist.

▷ **Boisterous Surf**
watercolour
20 x 30 cm (8 x 12 in)

A misty background works well with an angry sea and jagged foreground rocks dripping with white water. Note how the hint of red in these rocks helps to bring them forward.

of massed colours and shapes, that will give you an easier start to working in abstraction. Try magnifying some of the shapes to conform to your ideas. Base your abstract forms and colours on the actual rock, but simplify them, run them into one another and lose and add edges. Spatter, splashes, monoprints and spray can be interesting techniques to use with oils or watercolour.

▷ **Abstract rocks**

The dark rocks and background were painted normally with watercolour, then structure watercolour paint plastered over the middle foreground with a knife and allowed to dry. I then laid washes over this section, dropping in a mixture of colours. This is one way of creating a different foreground where the rock structures are in danger of becoming too monotonous.

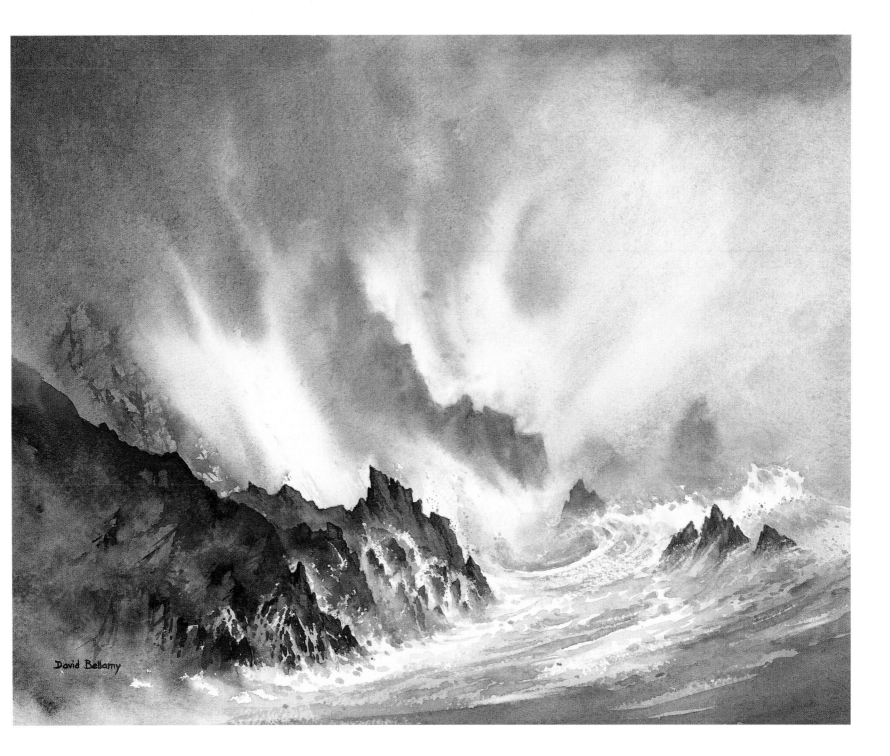

Caerfai Bay, Pembrokeshire

watercolour
30 x 46 cm (12 x 18 in)

Here the key features behind the planning of this watercolour have been outlined. Initially a simple studio sketch was drawn, with the main tonal relationships indicated, particularly at the focal point, which is the dark rock to the right of the pinnacles. With the top of the rock constantly being sprayed with surf it is catching the light, so the background adjacent splash has been slightly darkened at this point to highlight this effect. The part around the focal point is full of movement and contrast; by comparison, other parts of the painting have been kept fairly quiet. Note the variety of sea characteristics and how the various parts relate to each other and the rocks.

Warm colours in the cliffs contrast with the coldness of the water.

The diagonal thrust of the white splash suggests a strong sense of movement.

Shapely rock strongly etched against surf provides the focal point, with a combination of hard and soft edges and powerful contrasts of tone.

Quiet area of the painting helps to emphasize the dynamic focal point.

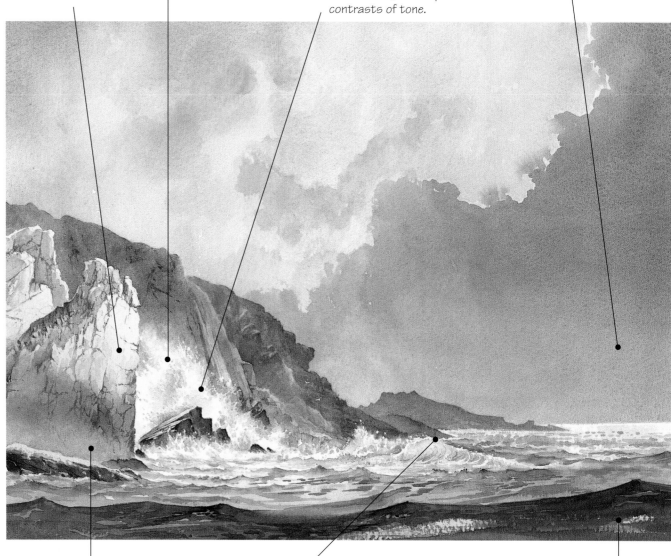

Lower cliff detail is lost in atmospheric spray, achieved by gentle sponging.

Colour spot on centre of wave highlights it and counter-balances the picture on the right-hand side.

Dark water in the foreground gives depth to the painting and is produced with a glaze of Burnt Umber and French Ultramarine.

exercise 9: Rendering rocks and cliffs

1 Try sketching rocks and cliffs of varying rock strata and textures. Work on some in direct sunlight and others in shadow. Seek out rocks in sunlight where a face caught in strong light casts reflected light onto a nearby surface. Simply work on the shapes and tones to begin with, in monochrome, then advance into colour. Use tone in the way I have done in the sketch of the Old Man of Stoer.

2 Look for rocks and cliff faces with interesting textures. This often varies throughout the day according to the angle of the light, and whether or not the rock is wet or dry. Initially carry out drawings only of textures, such as pitted rock, patterned rock, those covered in barnacles or seaweed, and so on, ignoring the actual shapes. When you feel more confident in your drawing attempt to render the whole rock shape with textures.

3 Carry out a painting of Skomar Tower in your chosen medium, keeping the sky fairly simple. Try to inject a feeling of a sunny day and avoid too much rock detail. There is no need to put too much emphasis on the sea as we are mainly concerned with the rock and cliff structures here. Where will you place the large foreground green rock? At present it is a little too central. My watercolour is on page 124.

◁ **Old Man of Stoer**

▷ **Skomar Tower, Lydstep**

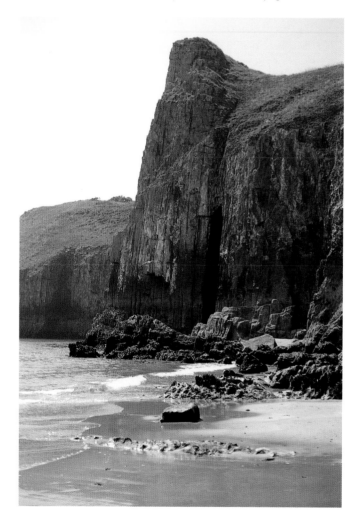

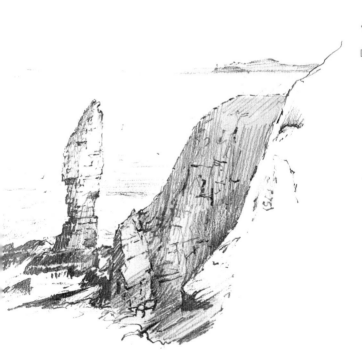

12 BOATS & HARBOURS

Boats can be the most beautiful, yet difficult, of subjects and some students seem bent on the idea of making them even more complicated than they need be. If you have problems drawing boats the techniques in this chapter will set you on the right course, but if you simply dislike boats then leave them out of the painting. This might be almost impossible in a harbour scene, but it can be done. They could also be partially lost behind figures, netting or other features.

If you do want to include boats, however, concentrate initially on drawing the easier boats and easier angles, leaving the more difficult examples and those with awkward curves until you are more conversant with the craft. If you are faced with a clinker-built boat, for instance, you could leave out the clinker lines and have no detail on the sides. As well as the actual studies of the boats themselves, look at how they relate to their surroundings and each other, whether aground or afloat.

▷ Model boat

A model boat with realistic lines can be effective for drawing practice. It can be positioned at a variety of angles and heights, and lit by an angle-poise lamp.

▷ Polperro, Cornwall
watercolour
23 x 16.5 cm (9 x 6½ in)

Polperro rises high above the harbour, a feature that can make life complicated for the artist. Much of the house detail needs to be reduced or lost completely, with more focus on the immediate dwellings and boats. I love harbours when the tide is out, getting down into the mud and seeking out new angles. If you cannot manage the big view look for the hidden corners.

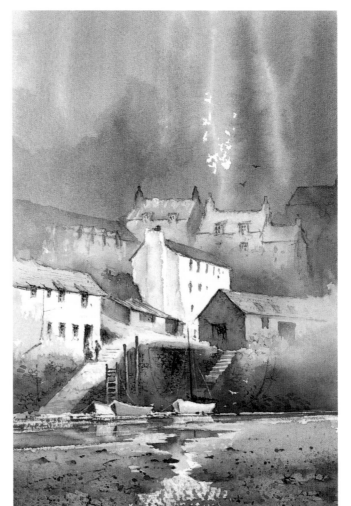

▷ Whitby Harbour, Yorkshire
watercolour
20 x 27 cm (8 x 10½ in)

With such a lot of detail in the painting I chose to use Waterford hot-pressed 300 gsm (140 lb) paper. Note how the background buildings have been treated, with just a suggestion of detail, although I could clearly see much more. This imparts a sense of distance. Red roofs draw the eye in and I especially enjoyed working on the harbour wall with its varied colours and suggestion of stonework. Cobles are not the easiest of boats to draw, but it is important to get a sense of place by rendering them as best you can.

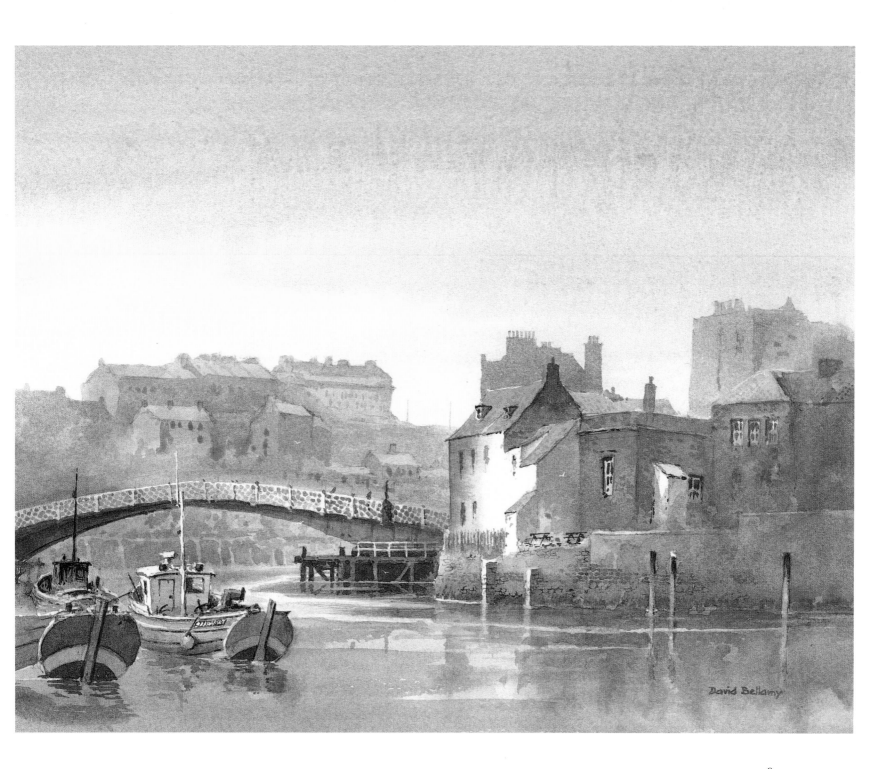

David Bellamy

⇧ **Tugs**

Studies of all types of boats make useful references for future work. In the right-hand tug construction lines help to define certain angles.

BOAT BASICS

Like many features, the further you are away from boats the easier they are to render, as detail becomes less obvious. The critical point about drawing boats is the angle of viewing. This includes the height from which you observe the boat and whether the boat is tipped over to one side. If your eye level coincides with the gunwale and you are positioned directly broadside to the craft you are normally looking at it from the simplest viewpoint. To make an easier start seek out a boat propped upright on twin keels or by a post at the side. A higher observation point that shows part of the inside of the boat and the far gunwale can only complicate matters at this stage. However, if this is what is presented to you it is best to draw the near side of the boat first and then the far gunwale, perhaps drawing in weak dots or reference points before rendering those details.

Drawing becomes more complicated when you change your viewpoint to somewhere on the bow or stern quarter. There is no formula to cope with this – the 'figure of eight' method only works on certain hull shapes and then has limited scope. Observation is the key. It is vital to relate each feature to its neighbour, so work lightly in pencil at first. Do not erase mistakes until you have almost completed the drawing, because you may well repeat the same mistake in the same place. When you are confident

that all lines are in the right place you can strengthen them if you wish. While you can lose the more difficult parts of a boat by placing figures or detritus in front of the awkward part, there is no real substitute for careful observation and studies.

I usually find it helps to begin with a baseline – this can be the waterline if the boat is afloat, or where the keel rests on the ground. You may need to use the nearside gunwale for this. From the baseline it is then easier to relate all the other features of the craft, all the time comparing sizes and position. You may find it helpful to construct a rectangular box around the boat with light construction lines. This can be a great help with the perspective. Sterns, prows and cabins can trap the unwary as some have raked lines and subtle angles. Hold a pencil vertically at arm's length to coincide with the feature to help you judge any difficult angles. Drawing from a model boat will help improve your work, but do ensure that you obtain a model with realistic traditional lines. By altering the angle and direction of light on the model there are endless possibilities.

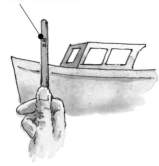

Use a pencil held vertically to compare the angles of boat features.

⇧ **Assessing angles with a pencil**

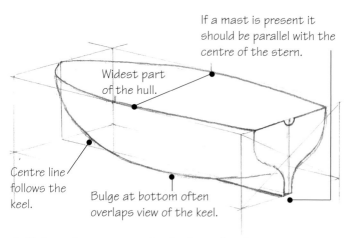

If a mast is present it should be parallel with the centre of the stern.

Widest part of the hull.

Centre line follows the keel.

Bulge at bottom often overlaps view of the keel.

⇧ **Using a box construction for boat drawing**

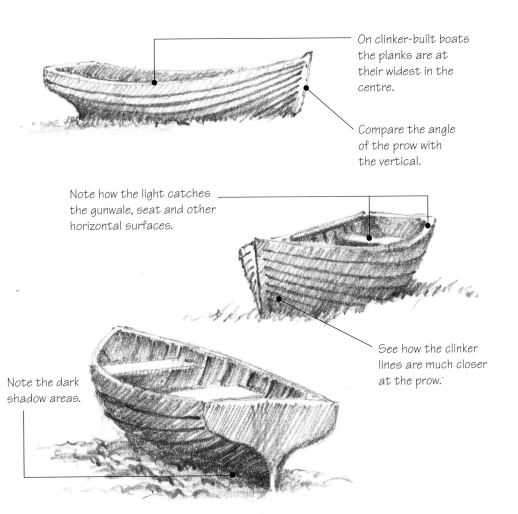

On clinker-built boats the planks are at their widest in the centre.

Compare the angle of the prow with the vertical.

Note how the light catches the gunwale, seat and other horizontal surfaces.

See how the clinker lines are much closer at the prow.

Note the dark shadow areas.

⇦ Simple boat structures

Here are three of the more useful angles on the same boat. It is of great benefit to draw it from several differing angles when you locate a superb boat, as it can substitute or be added in a painting.

BOATS AS A FOCAL POINT

Boats work well as a centre of interest, and if you have a number scattered around the painting it is best to have one or a single group emphasized to act as a focal point. This can be achieved by employing strong contrasts of tone, brighter colours and more detail than on other boats in the picture. Obviously, larger vessels will draw the eye. Resist the temptation to sprinkle boats all over the painting just to fill up spaces. Group them in one or two clusters or as individual boats with possibly some suggested more distant ones elsewhere if it is a busy location. Boats, of course, can be used to support other features in a composition. Use their ropes and chains as a lead-in, as well as puddles and channels gouged into the harbour mud by their keels. Alter the angle of these to suit your composition. Ropes, masts and chains can also be effective in breaking up long, strident lines of harbour walls and buildings.

With boats the trick is to find a really superb example – one that appeals to you and is not cluttered with detail. Spend some time drawing and photographing it from a number of different angles. Having views of it pointing to the left and right is extremely handy, as it can then be placed in many paintings. With your pencil you can transport it from the Orkneys to Padstow if you need to, so long as it does not have strong local characteristics, such as with the Yorkshire coble. When you come across a stunning composition with the ugliest boat in the world at its centre you can then substitute that with your favourite.

HARBOUR COMPOSITIONS

In most harbours the amount of detail can be overwhelming, so it helps to simplify things considerably. One powerful method of reducing detail is to create a 'harbour haze', which will both lose detail and suggest depth at the same time. If you paint everything as clearly as you see it, the final effect is likely to be confusing. By painting the more distant features in a kind of weak silhouette, with the middle distant ones showing a slight suggestion of detail and the far distant ones completely devoid of detail, you can then concentrate the strong detail and

demonstration: Outbound Freighter

Watercolour 18 x 30 cm (7 x 12 in)

Sketching on the Mersey kept me on my toes, as I had to keep a wary eye out for approaching ships, then quickly change my sketching angle to capture them. They seemed to hurtle past, although, of course, the pace was really quite sedate. For this watercolour I used 300 gsm (140 lb) hot-pressed Saunders Waterford paper.

⇨ Stage 1

After applying masking fluid to the ship's superstructure I began by laying some Naples Yellow to the left of the sky centre, then lowering a mix of Cadmium Red and Cobalt Blue into it and across the building in the background. When all this was dry I brushed weak Cadmium Orange over part of the Naples Yellow and while this was wet some darker Cobalt Blue and Cadmium Red over the bottom left and also to define the building.

◁ Stage 2

I used more of the dark wash for the distant skyline astern of the ship, then modelled the building. Realizing I had made a drawing error around the lettering I then re-drew this part. After inserting the cranes I introduced the water with small dabs of Cobalt Blue and Burnt Umber around the ship, and larger, sweeping strokes of the same mixture in the foreground.

Stage 3

The hull was painted with a weak Cadmium Red plus French Ultramarine at the bottom, and a stronger mix that included Burnt Umber at the top. I then removed the masking fluid from the ship's superstructure.

Stage 4

With a rigger I applied detail to the freighter, then subdued the building with a weak wash of French Ultramarine and Burnt Umber. Finally, I added a few more details to complete the painting.

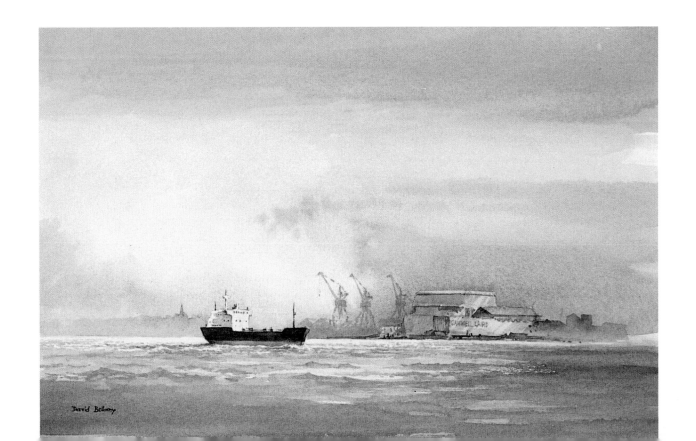

David Bellamy

◁ **Pool of London**
wash and line

This sketch was carried out one cold January day when an icy easterly blew up the Thames. Tugs and lighters make interesting subjects, and the sailing barge *Victor* was moored just below Tower Bridge. I moved to a position where St Paul's Cathedral stood to the left of the bridge, then later moved again and inserted the British Telecom Tower nearby, making a note of the erroneous position.

contrasts on your focal point. In certain atmospheric conditions this happens naturally, but most of the time you will need to exaggerate the effect.

LINEAR PERSPECTIVE

Thankfully, most of coastal landscape painting does not involve complicated perspective, but with harbours it can be a different story: harbour walls, buildings, steps and so on can cause the artist many problems. The first thing to do is to establish where your eye level occurs. This does not need to be absolutely exact. If you wish, you can lightly draw a horizontal line across the paper to represent the eye level. All horizontal lines such as the ridges of roofs, the eaves, bottoms and tops of walls, window ledges, door lintels and the harbour waterline can then be drawn relative to this eye-level line. Those lines above

your eye level will drop down as they recede, while those below your eye level will rise as they recede. The higher or lower they are away from the eye-level line, the more acute and exaggerated is the angle that they drop or rise. This is best understood by using a vanishing point, which will be found at some point further along the eye-level line, as shown in the diagram on page 102. Try drawing outline sketches mainly concentrating on the perspective.

Be aware, however, that too rigid adherence to the rules of perspective can detract at times from an interesting work. Many old buildings and harbour walls are so wonky and lop-sided that an exaggeration of their perceived defects lends enchantment. Abereiddi in Pembrokeshire has cottages with windows that defy all conventions of perspective and others that once had outrageously skewwhiff roofs

▷ **Pool of London**
oil on canvas
45 x 60 cm (17½ x 23½ in)

This is a larger oil painting done on canvas, with an underpainting of Raw Umber. The Thames has always been of great interest and often exudes a marked atmosphere. Many of the more distant edges have been left soft and vague as there is so much detail in the scene.

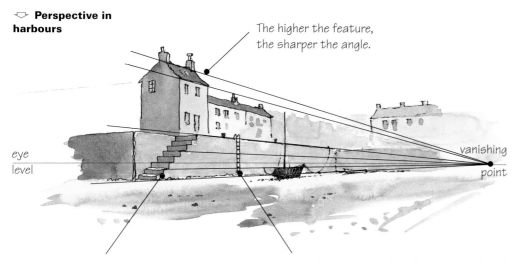

The higher the feature, the sharper the angle.

eye level

vanishing point

Lower two steps are below eye level and hence reveal the tops of the steps.

Even the ladder rungs and window frames should adhere to the rules of perspective although in reality they may be too small to worry about.

FIGURES

Harbour scenes will appear rather ghostly without any figures, so try to include some. As figures draw the attention of the viewer try to position the most prominent ones at or close to the focal point. Figures need some 'breathing space' – that is, ensure there is little detail around the figures, otherwise they get lost in the mass. It also helps to make the figures look as though they are involved in some activity – cleaning a hull, mending nets or tying a rope, for example. You might like to add a little more colour to the figures' clothing, or at least to those you wish to stand out. Introducing groups of figures can provide variation, but avoid having too many individuals by running some of the figures into one another. Have some of them carrying objects.

that, unfortunately, were battered during a storm. When repaired they were given perfect symmetry – a sad day for the artist! Look for the unconventional, but be aware of the basic laws of perspective.

Camusterrach, Applecross
pastel
20 x 30 cm (8 x 12 in)

This pastel was done on P400 glasspaper. I wanted to project a light, airy feel to the scene, situated on the Applecross peninsula in Northern Scotland. A Chinese junk lay away to the right, but I felt it would look a little out of place in this picture. Here and there in the walls and stones I have flicked a variety of colours to give the shadow sides in particular a sense of vibrancy that a dull grey shadow colour will not achieve.

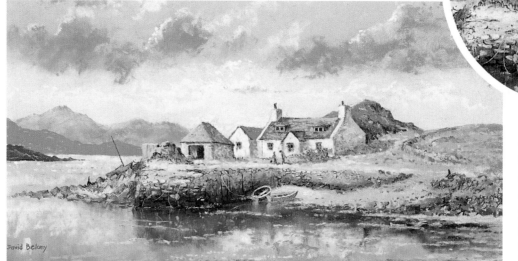

David Bellamy

Detail from Camusterrach

This shows the various colours that have been applied to the harbour wall area in a dabbing stroke to create a sense of roughness, colour and shadow. The lines were picked out with a pastel pencil.

exercise 10: Working on boats and harbours

1 Find a simple boat and try sketching it from a number of different angles, beginning with a simple broadside view and gradually working from more complicated angles. Use a sharp pencil and include shading to create a tonal study. If you prefer, try using a box construction as an aid. Fill several pages with studies of the boat.

2 Work on a number of different types of boat, including some clinker-built ones and larger, more detailed ones.

3 While you are working on the boats sketch any interesting figures and groups that appear, especially those who are engaged in activity.

4 Sketch a harbour scene, starting with the most important parts and using the silhouette technique on the background (see example on page 112). Harbour scenes can be quite busy, but take it a step at a time and do not feel you have to include everything.

5 Have a go at painting Solva Harbour. You may wish to subdue the upright yacht with the tall mast on the left. My own version, in watercolour, is shown on page 125.

⇧ **Figures in harbour**

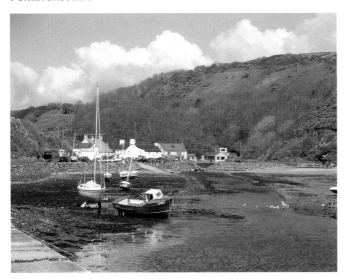

⇦ **Solva Harbour, Pembrokeshire**

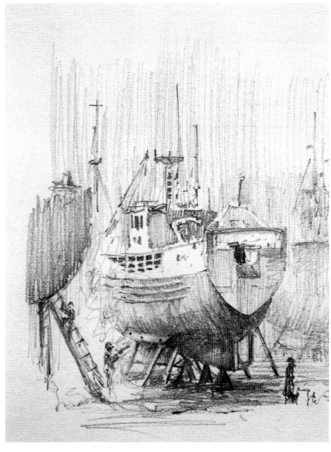

▷ **Shipyard in Reykjavik**

◁ **Figures in harbour**

13 SKETCHING AFLOAT

Sketching from a boat, canoe or other flotation device can give you an interesting new perspective on coastal scenery as well as pure marine scenes involving just the sea with maybe some craft. It can be an easy and often serene way of reaching subjects, although there are times when the opposite may apply. Drama is heightened by viewing cliffs, caves and rock arches from the sea, and wildlife becomes more apparent. Wild rock architecture can be the stuff of legends, of monsters, serpents and sea-goblins (there are a lot of these in Iceland, according to their paintings!).

Boat cruises leave many ports and harbours to view scenery or wildlife and give you the opportunity to explore the coast for a modest charge. If you mention to the skipper that you are interested in obtaining some pictures he will often oblige by giving you a few extra moments at the spot. Taking a quick photograph is usually no problem, but if you are sketching then you need to work fast. Hiring a boat for the purpose of sketching a piece of coastline can be rather expensive, but if you have a group then the cost can be shared. This way, the boat will go where you want it to, within reason! You could also join a boat-based painting course.

PREPARING TO GO TO SEA

Keep your sketching gear to a minimum, and leave behind your more expensive items. One student had

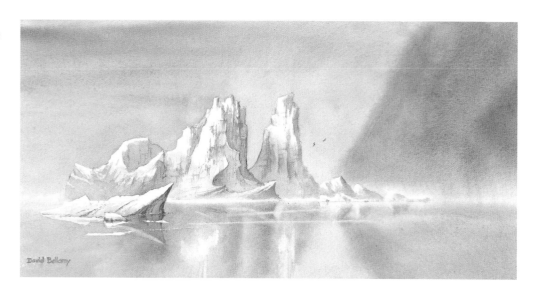

⬆ **Icebergs in Mist, Iceland**
watercolour
15 x 33 cm (6 x 13 in)

Icebergs loomed out of the misty atmosphere as we sailed across the lagoon. The colours varied through the cool spectrum, with the occasional striped berg. I did several sketches mainly with water-soluble pencils, including the Arctic Terns whenever I could.

an expensive sable brush swept overboard on a sea trip during one of my boat-based courses. A plastic liner in your bag or rucksack will help keep out any sea water swilling around the deck, and likewise cameras should be kept in waterproof containers or bags until needed. Sea water will completely ruin cameras. I use waterproof drysacks or a Pelican airtight case, which is so robust that I even take it

▽ **Trawler on Loch Nevis**
watercolour
20 x 30 cm (8 x 12 in)

The studio sketch for this watercolour can be seen on page 52. Apart from the colours on the fishing vessel as it heads into a rain squall, the painting is a monochrome.

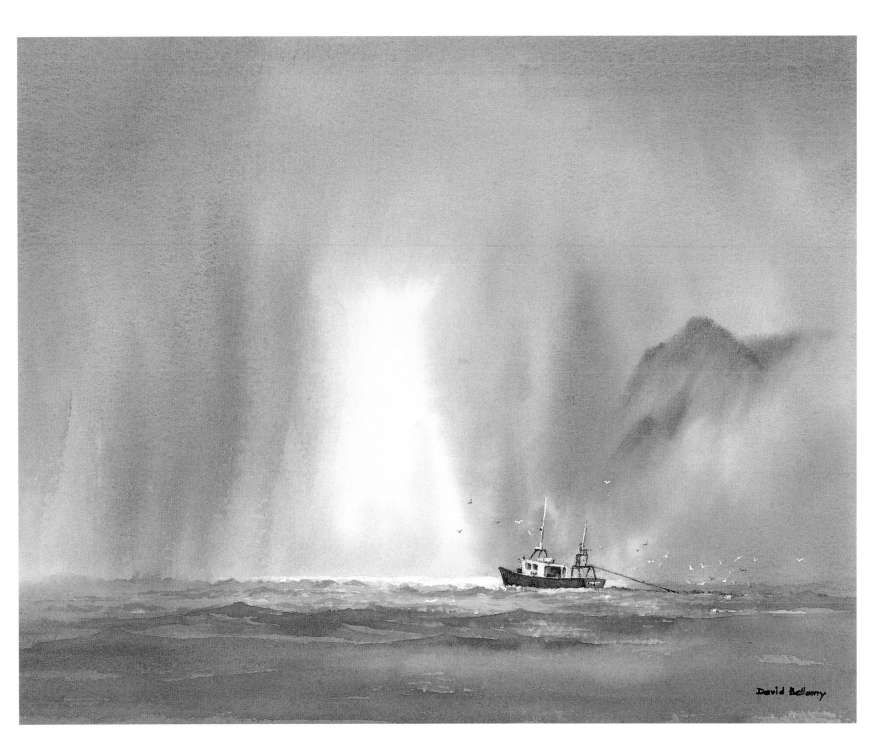

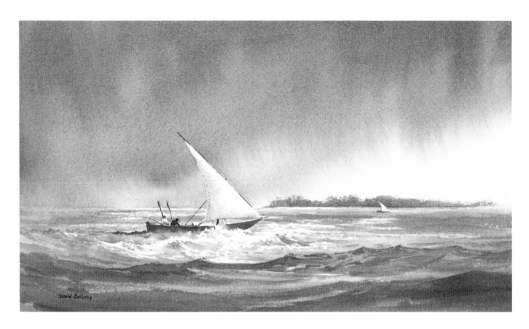

⌂Fishing Craft off Zanzibar
watercolour
20 x 33 cm (8 x 13 in)

It helps the composition to have the main boat sailing or looking into the picture and not near the extremities or looking out, though it does not matter if smaller, less significant boats do so. This boat was sketched while we were out at sea on a dhow. The sky is noteworthy for its simplicity: Naples Yellow laid across the bottom half, then immediately a strong wash of French Ultramarine and Cadmium Red brought down over it. The white sail was protected by masking fluid.

when abseiling down underground waterfalls. It is worth taking several pencils to avoid having to waste time sharpening any during the trip. Take two or three sketchbooks of varying sizes. You may find one will become wet from spray or wave splash.

WORKING QUICKLY

Once you are under way note where any waves are causing spray or splashes to come over the gunwale so that you can avoid those positions when taking photographs. These positions will inevitably change as the boat alters course, so keep a wary eye on the matter. Searching ahead through binoculars can alert you to subject possibilities. As you approach a subject below a line of cliffs, start drawing in a baseline and putting in general lines to give yourself a start. This is especially important if you are on a normal cruise. If the boat is simply sailing straight past your chosen subject there will hardly be any time to capture the

details, as the perceived rock configuration will change rapidly. Do bear in mind, though, that you will probably have a second chance on the return leg. Ploys such as 'Could we please go in a little closer to see that pinnacle?', or even 'Is that a seal on those rocks?' will often give you precious extra minutes, but there is a limit to this, of course. As you depart the scene make a note of the colours and tonal relationships of both the rocks and the sea.

With a boat dedicated to your interests life is more relaxed and the boat can be stationed in the optimum position. Depending on the sea conditions, however, it will move in or out, or go round in circles, and generally change your viewpoint gradually, so you still need to work reasonably quickly. With rock scenery it is easy to lose your sketching position. Try to get a general impression rather than too much exact detail. If you start feeling seasick look up at the cliffs or distant view. This is especially likely when looking at someone else's work, as you are both swaying at different tempos. I have turned green on occasion while advising a student out at sea – usually when it is the tenth student's work I have looked at.

Canoes are an excellent means of reaching inaccessible coves, sea caves and confined spaces to explore, and they make it easier to land on a wild coastline. Sketching from a bobbing canoe can try your patience, so it helps to operate in pairs, one holding the craft together while the other sketches. Most of your equipment will become swamped, so plan accordingly. This, of course, will only appeal to the more adventurous.

Given reasonable conditions I have at times swum across short stretches of water to sketch a scene that is otherwise inaccessible, towing my sketching gear in

a drysack. A small flotation device ensures that it stays afloat. This method is usually combined with the sport of coastal traversing – moving along under the cliffs, above and in the water – but it is vital to be sure of the tide state. At times this yields spectacular results, but it can be fraught with danger where strong currents may occur.

THE OPEN SEA

Keep an eye out for other craft at sea and take advantage of any sketching possibilities. Work on drawing the vessel while it is within range – the sea and background can be added afterwards, but the craft will not stay there for ever. Observe how it 'sits' in the water and how the water relates to the hull. With a hired boat you could hold station at a constant angle and range from the subject vessel and have more time to sketch it. Sometimes on a boat-based course we have had two vessels available and when one was the *Eda Fransden*, a gaff cutter, we took the opportunity of staying ahead for about an hour to sketch her. Backgrounds, of course, can be inserted into a painting later, using images from the trip, but not necessarily that which was actually behind the vessel. During the more quiet moments it is useful to sketch any distant cliff, hill or mountain scenery that can act as a backdrop to a picture. Aim always to achieve an impression of the character of the local cliffs. Enjoy the trip!

▽ North Haven, Skomer

Skomer Island from a boat on a lovely early summer evening is a paradise for bird-watchers. There were thousands of puffins in the sky at once. I could not work fast enough as I was sketching, making notes, taking the odd photograph and also using binoculars.

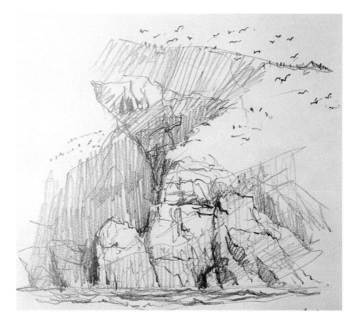

▽ North Haven, Skomer, Pembrokeshire
oil on canvas panel
25 x 36 cm (10 x 14 in)

This painting was produced from the original pencil sketch. My aim was to capture the beautiful warm light that flooded the bay and made interesting shadow patterns on the rocks.

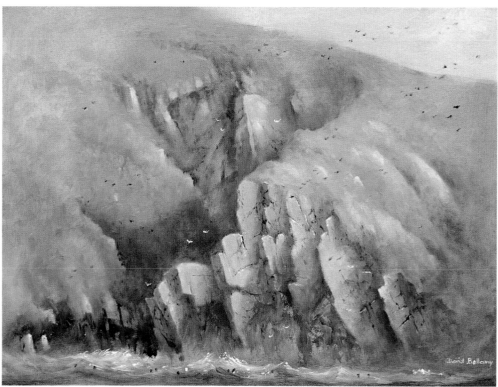

▽ Eda Fransden

We stood ahead of the *Eda* for about an hour as she ploughed through the Sound of Sleat. As well as making a number of rapid sketches I made several useful diagrams to explain to myself for future reference how the sails, rigging, masts and so much more worked. Here are some of my efforts.

White

Natural wood masts

Light Red

Natural wood

Dark green

Red

Although this top sail was white, it appeared dark against a light background.

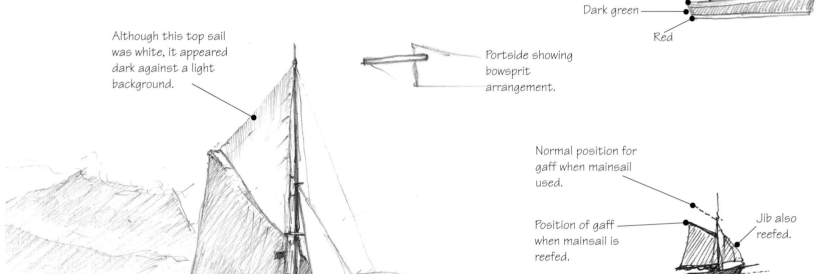

Portside showing bowsprit arrangement.

Normal position for gaff when mainsail used.

Position of gaff when mainsail is reefed.

Jib also reefed.

Eda in the Sound of Sleat with 4 of her 5 sails up.

exercise 11: Working afloat

1 If you are able to get out on a boat try making rapid sketches of coastal features, eliminating a great deal of detail and concentrating on the main aspects. The sketches need not be complicated – you may well find in some instances that the most you can do is similar to my Sgurr of Eigg drawing. Also look out for opportunities to sketch other vessels at sea. This is superb practice at picking out the essential features of a subject.

2 Do a painting from the photograph of *Eda Fransden*, seen here in the Sound of Sleat. You may wish to change it to a vertical format. My watercolour is on page 126.

◁ **Eda Fransden in the Sound of Sleat**

△ **Sgurr of Eigg from the sea**

This rapid pencil sketch was done as we approached the harbour at Eigg. The peak was no problem as it is some distance away, but I had to work quickly on the closer elements, and felt it did not really work.

14 ATMOSPHERE & LIGHT

Atmosphere wields the passion in a scene, and can send both artist and viewer to great heights. Without atmosphere or a sense of mystery, a landscape or seascape loses a precious ingredient, something that sets a painting apart from the ordinary. As Corot said, 'Reality forms part of art, feeling completes it'. Most of the paintings in this book evoke a certain amount of atmosphere, and once you become competent at the general painting of a landscape it is a good time to consider how you can improve the scene in this way.

Obviously without light we cannot see our subject, but the artist is more concerned with controlling that light to gain maximum advantage out of the composition. Examples of this would be to strengthen light around the focal point and subdue it elsewhere, or create sparkle on water to excite the eye of the viewer. By introducing reflected light you can brighten up an otherwise dull passage. Dappled sunlight falling on grass, rocks or whatever can evoke memories of hot summer days, while warm evening light touching the cliffs can suggest long days lingering in beautiful places. Light and atmosphere are inextricably linked, providing the most potent of images even on the dullest, foggiest days, or when a rain squall threatens to obliterate your subject.

GETTING TO GRIPS WITH SKIES

Skies are a fundamental key to light and atmosphere, yet few artists take the time to paint interesting and

⬆ **Coast near Rhoose Point**
pastel
23 x 30 cm (9 x 12 in)

I used Somerset velvet paper – Newsprint Grey – for this moody pastel. Much of the foreground was left untouched as the tint is lightfast. There is some pastel pencil work in the foreground.

◊ **Newquay Nocturne, Ceredigion**
oil on canvas panel
30 x 41 cm (12 x 16 in)

Harbours lend themselves to nocturnal works because of the combination of lights, water and a host of subject material, even on non-moonlit nights.

lively skies. Often even professionals rely on some slick and repetitive sky formula. Like everything else, to produce interesting skies you have to work at it. Simply relying on the sky in a photograph you have taken is normally pointless, as nine times out of ten it will be fairly devoid of detail. Unless you want fluffy white clouds in a mainly blue sky all the time – which can become a little boring – you will need to work in less than perfect weather. However, this can often be done from your bedroom window, the car, or somewhere sheltered. It is rare that I paint the actual sky observed over a subject – normally I take a sky from my bank of sketches, knowledge and photographs, finding one suitable for the desired composition and mood. It is a matter of grasping every opportunity to capture an interesting sky.

Whenever you notice an impressive sky or atmosphere it is vital to record it on paper and film. When taking a photograph of the sky try to include as little of the ground objects as possible, as these will affect the exposure and hence lose sky detail and tonal contrast. Try to think of clouds as a definite subject in their own right, so that ground detail is fairly unimportant by comparison. The sky changes rapidly, so you need to work quickly with art materials, concentrating on the most exciting area. Watercolour, charcoal and water-soluble pencils work well when rendering the sky. Compare colours in different parts of the sky: for example, one part might be absolutely white while the clouds further away might appear a distinct pink in comparison, yet in isolation both areas may well look white. Look for a focal point in the sky, and the source of light. Observe how the sky integrates with the land and sea, including the subtle nuances of colour and tone.

EMPHASIZING MOOD AND UNITY

Creating a feeling of strong mood involves unifying the scene with mixtures of a series of similar colours, with any note of discord only introduced into a limited part of the painting – usually the centre of interest. To achieve this I generally use one blue as a base colour. When this is mixed with other colours in various passages it provides a sense of unity. In oils or watercolours another method is to apply a glaze of transparent colour over the appropriate area once the painting has dried. Think carefully about your colours: are you aiming to set up a warm or cool effect? Maybe one part of the work will be warm, using perhaps reds or yellows, for example, and the rest cool, dominated by blues and greens. In watercolour tinted papers are superb for unifying

⬭ **Silhouetted background**

Harbours can become far too cluttered with detail, so the background silhouette approach can be useful, as employed in this watercolour of a tug scene near Greenwich. I could actually see plenty of detail in the far buildings, but it would not help the painting.

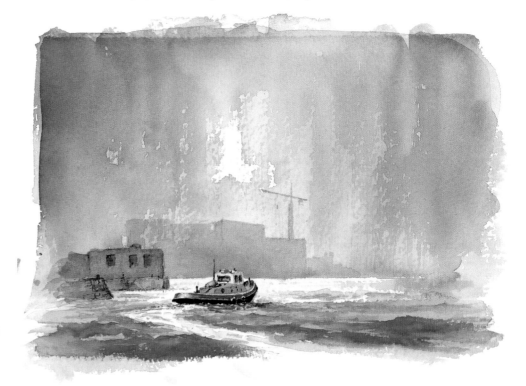

Ripples at sunset

In this pastel gentle ripples evoke a marvellous sense of timeless peace, accentuated further when combined with a setting sun. Beware, however, of too violent reds and yellows or too complicated skies.

Appledore, Devon

A small watercolour study done on Bockingford Blue tinted watercolour paper, mainly using Indanthrene Blue and Perylene Red, with white gouache for the cottages and highlights. Tinted paper is one of the best ways of achieving mood and unity in watercolour.

colours and you can choose a warm or cool tint. In oils or pastels use a support tinted to your needs.

HOW COMPOSITION AFFECTS MOOD

The injection of atmosphere and light into a painting is best considered at the planning stage before you even draw the first pencil line. Planning should not stifle passion. On the contrary, it should channel your efforts into creating a sense of mood fitting for your subject and treatment. While the basic need for a definite source of light, with its associated directional emphasis, is perhaps an obvious early consideration, think about which elements in the composition will be lit up, where the highlights will occur, and how all this affects each major feature. What sort of mood do

Unifying with a glaze

The boat and setting was painted in, including the darker diagonal shafts, and when all was dry I washed a light transparent glaze of French Ultramarine and Quinacridone Red over everything except the boat and light sea areas. This is one of the most powerful ways of unifying a painting.

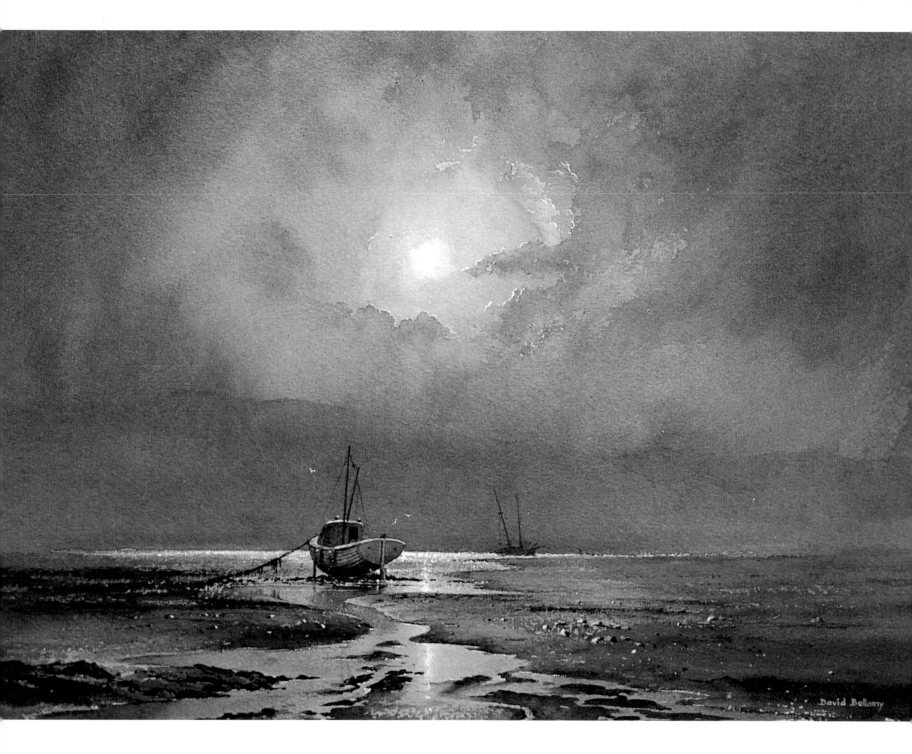

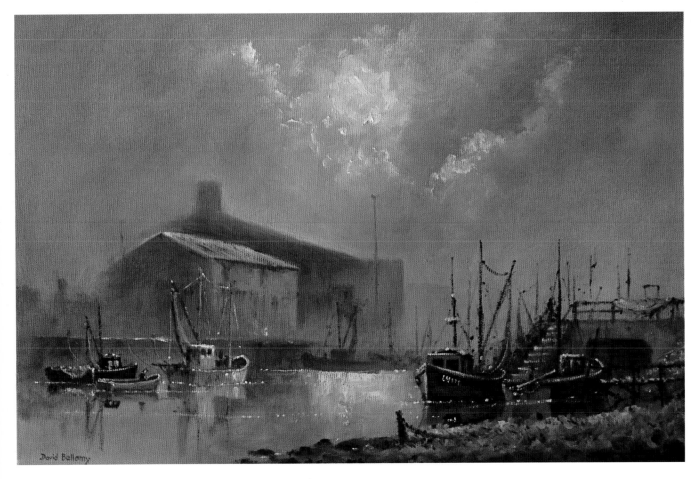

◊ **Fisher Fleet, Kings Lynn**
oil on canvas panel
24 x 34 cm (9½ x 13½ in)

I was quite knocked over when I
caught sight of the mass of
vessels here, but sadly many of
them sprout grass through the
decks and are slowly decaying.
In the painting I have introduced
a grey misty day to lose much
background detail and hence
apply more focus on the boats.

◊ **Boat at Exmouth**
watercolour
23 x 33 cm (9 x 13 in)

This scene was painted on de
Wint tinted watercolour paper
rated 'rugged' and, sadly, no
longer available. It is a biscuit-
coloured paper, and here I have
used Phthalo Blue (Red Shade)
and Indian Red, two powerful
colours that will easily kill the
tint where needed. The final
stroke was to enter white
gouache for the highlights.

you envisage: a storm or perhaps a breezy day with a
sea punctuated with white horses, or maybe a misty
cove with light shimmering through? Maybe the
distant headland would benefit from being partially
lost in a rain squall, or strong sunlight is needed to
highlight a rock pinnacle. As already mentioned,
studio sketches greatly help you with these
compositional considerations.

To suggest a calm day I find that a more horizontal,
perhaps elongated, format works well, playing down
any strong verticals in the scene. While any waves

should not be too large, you need to ensure that white
highlights provide a sense of life and movement.
Breezy, windy days can be suggested by giving the
clouds ragged edges and a diagonal emphasis, more
white on the surface of the sea and where it splashes
against rocks, and having gulls, boats and trees
leaning over to one side. Increasing the white foam
on the sea, accompanied by wind-torn spray,
mountainous seas and dark, wild skies can suggest a
storm. High, vertical cliffs and towering cumulus
clouds can add to the sense of drama. In oils and

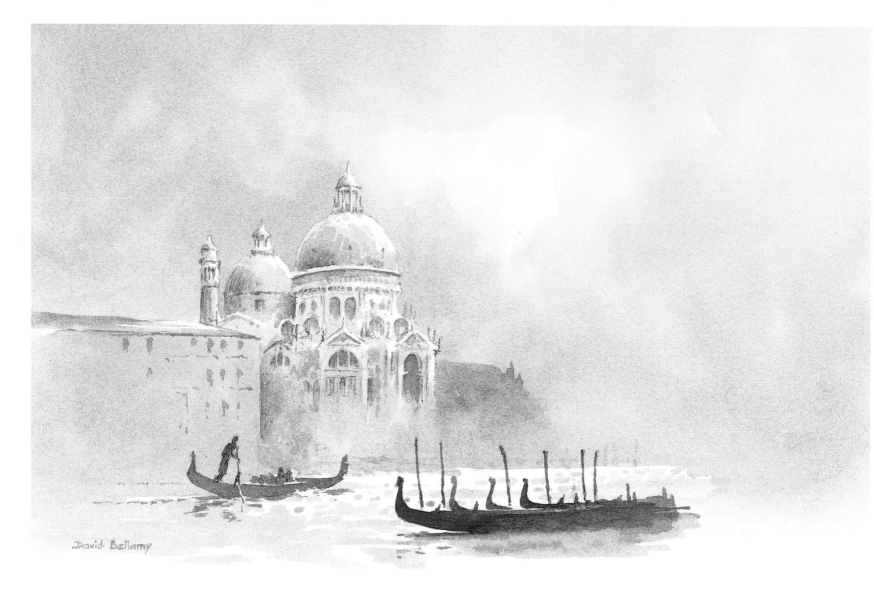

David Bellamy

pastels mist can be suggested by blending features into each other. This is best achieved in watercolour by the wet-in-wet method (see Chapter 4).

Introducing distant rain squalls can be very effective in losing headlands or for highlighting vessels at sea, as on page 105, for example, where squalls simplify the background.

⬆ **Santa Maria delle Salute, Venice**
watercolour
17 x 19 cm (6½ x 7½ in)

With so much detail, I decided on a hot-pressed surface using a mix of French Ultramarine and Quinacridone Red, with some Cadmium Yellow Pale in the sky. The white highlights are important. Note how the lower part of the building is lost in mist – this allows the passing gondola room to breathe. The foreground boats emphasize recession.

exercise 12: Studying mood and light

1 Choose an appropriate day for the type of atmosphere you wish to portray and attempt some sky studies in a medium of your choice. Seek out the most exciting part of the sky and begin there. Watch also for how the sky relates to the sea or land, and render this in your sketches if it exerts a significant influence on the scene. Back up your sketches with photographs.

2 Go out on a sunny day and concentrate on sketching the effects of sunlight falling on features, observing how strong sunshine bleaches out detail, how cast shadows appear and how objects are affected by light direction: from the side, behind your viewpoint and when the subject is backlit. Seek out white walls caught in the sunshine and how the reflected light from these affects other objects.

3 Carry out a painting of Robin Hood's Bay, Yorkshire, with strong emphasis on the atmosphere, considering sunlight and shadow in particular. My version is on page 127.

⇧ **Robin Hood's Bay, Yorkshire**

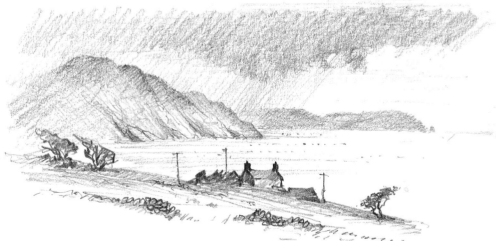

◊ **Niarbyl Bay, Isle of Man**

15 GALLERY OF PAINTINGS

This final chapter contains my responses to the painting exercises in previous chapters. Until you have carried out the exercises you will probably find it best not to study these paintings, but compare them closely with your own afterwards. Do not worry if your efforts do not match mine, or even if they wildly differ, for we all have an individual way of looking at a scene, which is part of the fun of painting. Anyway, I would probably treat it quite differently if I painted it again. What you should look for, though, are those places where you feel unsatisfied with your effort. How have I tackled the same problem? What lesson can be learned from that? What points stand out regarding the way the overall composition has been arranged? What forms the centre of interest, and how has it been highlighted? How has a sense of recession

▽ **Beach, evening light**
watercolour
14 x 25 cm (5¹/₂ x 10 in)

I have not tried to be too accurate with the rock, but mainly wanted to retain the lovely evening atmosphere that pervaded the scene. I felt that the sky needed some birds for interest and to give it some life.

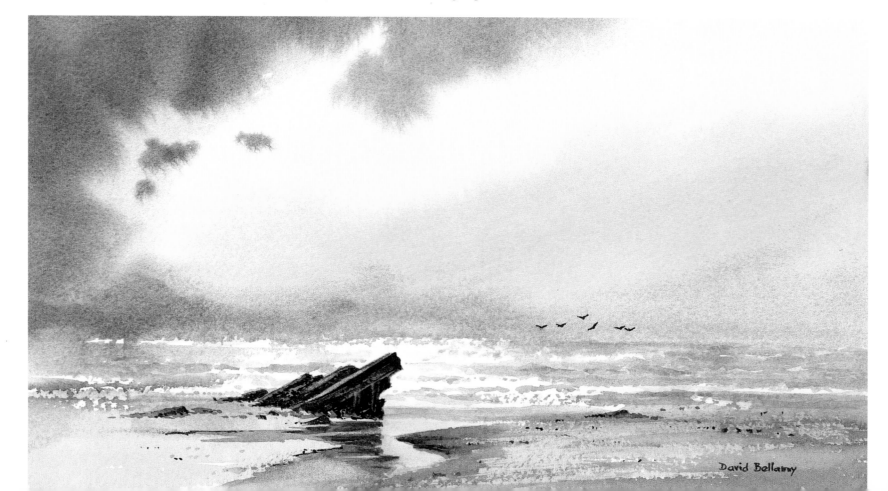

David Bellamy

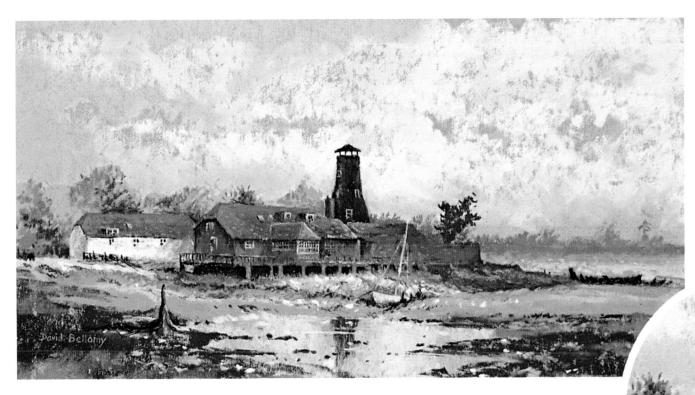

▽ Detail from Langstone Mill

This shows up some of the short pastel strokes used on the roof to illustrate tiles that are a lighter red than the main area. Also note the finer pastel pencil work on the windows and railings.

been achieved? Note how similar problems occur in many of the subjects, and they have not all been resolved in the same way. Even if you have used a different medium it will still benefit you to carry out these observations.

Repeat the exercises when you feel the time is right, and work especially on those parts that have caused you problems. Consider changing the mood, such as bringing in mist or sunshine, or changing the season, adding figures, pushing the focal point further into the picture or changing the foreground. It is amazing how much mileage you can get out of just one scene. Of course, you may also like to try it in a different medium next time. Watercolourists in particular benefit from working in an opaque medium from time to time, so do give the other mediums a try!

△ Langstone Mill, Hampshire
pastel
15 x 30 cm (6 x 12 in)

This pastel was done on P400 fine quality glasspaper. I began by scrubbing all sorts of light colours across the sky. These buildings are really fitting for pastel work with the odd splodge of red here and there on a dull part of the roof. I also like the stilts, which are green lower down. I had to re-describe the dark areas underneath after painting the stilts, in order to make them stand out sharply. When making the original sketch I wandered out into the glorious mud – there is a route through the mud, but take care about wandering off it, even in wellies!

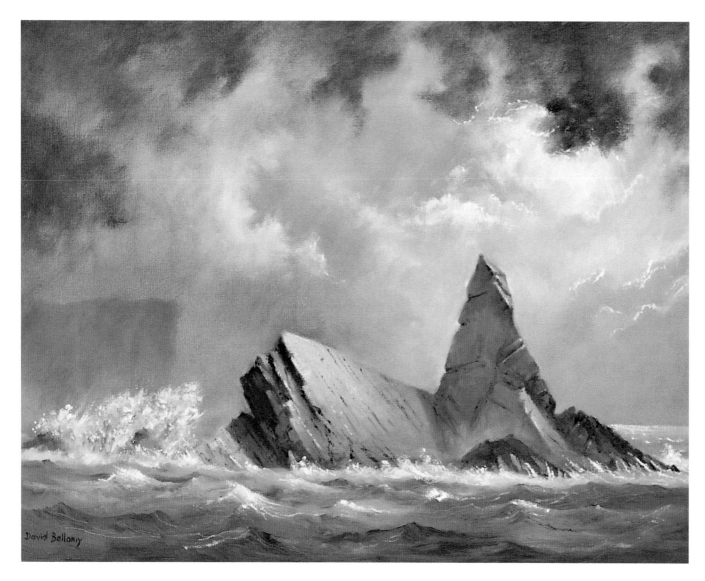

◊ **Brancaster Staithe, Norfolk**
watercolour
20 x 33 cm (8 x 13 in)

Fleecy clouds on a sunny day make life so much easier for the landscape artist, and here I have introduced two quite large areas of dark cloud shadow aimed at losing the incredible amount of distant detail. You could pick out any of the houses or boats as a focal point. There are so many different ways to work this scene that you could do it again and again – even with a storm or winter trees perhaps. My foreground boat is not absolutely necessary, but I liked it, so in it went. The painting was done on a Not 300 gsm (140 lb) paper.

△ **Church Rock, Broad Haven**
oil on canvas
30 x 41 cm (12 x 16 in)

This picturesque sentinel standing in the middle of the bay is much painted, yet it demands rough seas to be seen at its best. I have merely suggested Stackpole Head in the background so that all eyes feast on the rock itself. The splashes of Cadmium Orange, sharp fracture lines and cast shadows all help to give the rock interest and solidity.

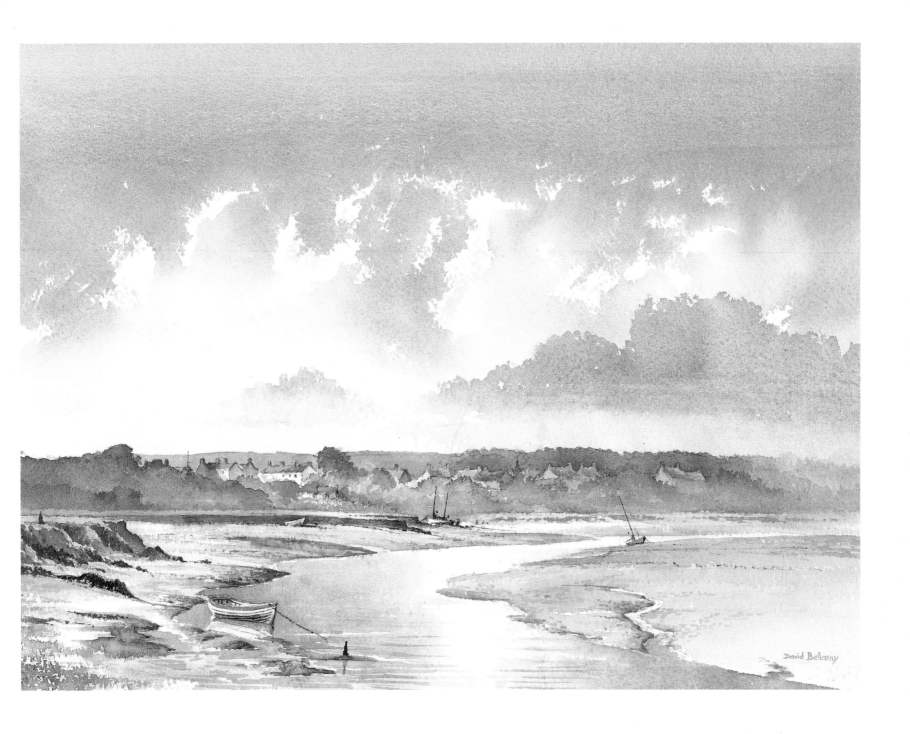

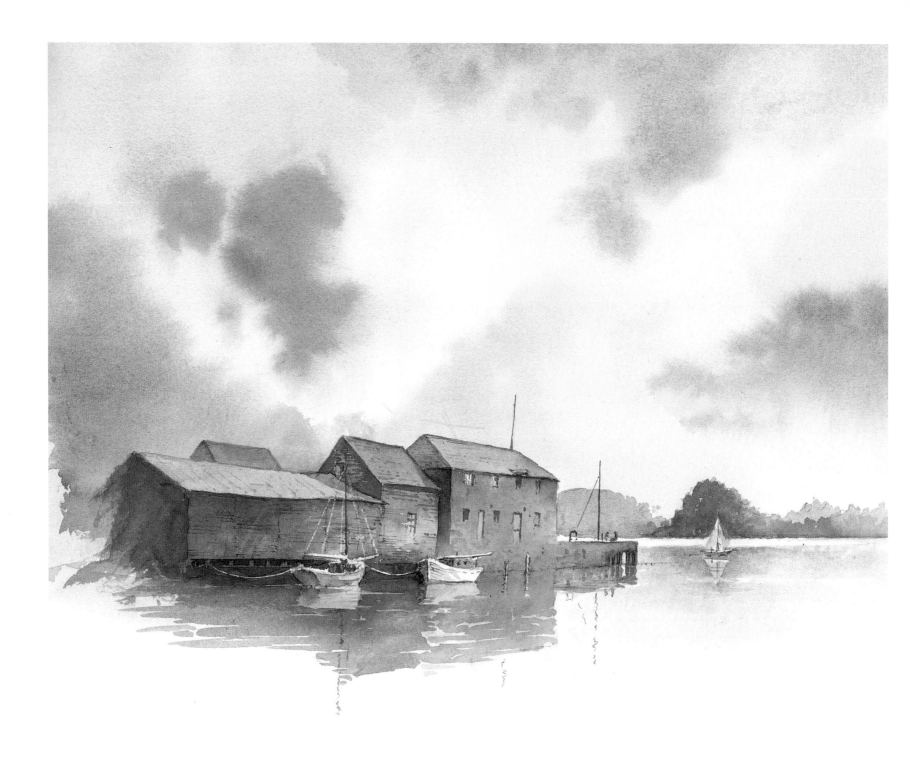

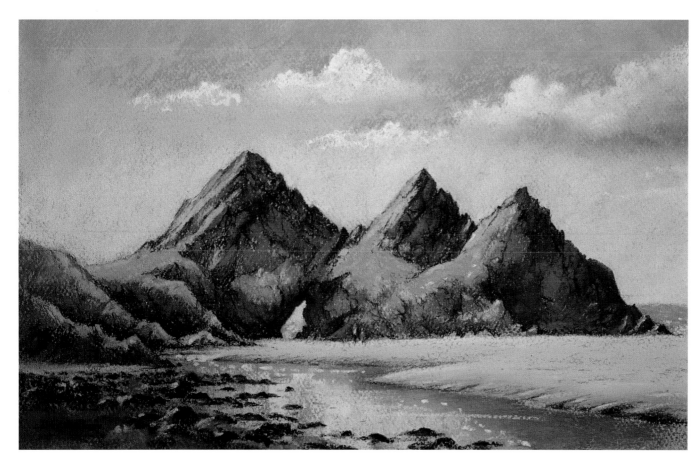

Three Cliffs Bay, Gower
pastel
23 x 30 cm (9 x 12 in)

For this scene I used a warm grey Canson paper and revelled in the rock scenery. Naturally I have more information than I have given you for the exercise, and you may not have realized the amount of orange in the lower rocks, in the darker area. This helps to draw the eye in to the archway, which is the focal point. I have introduced figures to make doubly sure and, of course, the stream wanders that way as a lead-in.

Dell Quay, near Chichester
watercolour
22 x 27 cm (8½ x 10½ in)

My version of this scene has been drastically simplified, with a vignetted foreground. The sky was done by washing water across the paper, which was 300 gsm (140 lb) Not, then dropping in strong blues after a few moments, to create the lovely soft cloud edges. Masking fluid was used on the light boats.

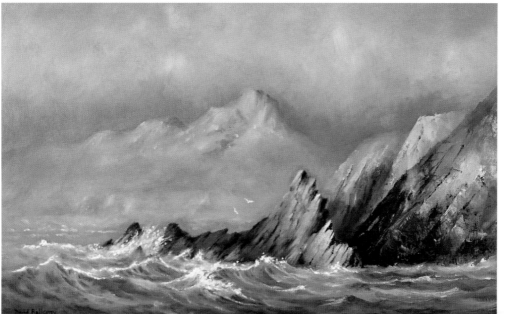

Porthselau, Pembrokeshire
oil on canvas panel
25 x 36 cm (10 x 14 in)

My focus here was on the crag being raked by wave after wave. The colouring on the rock is fascinating, as indeed are the cliffs all round this part of the great sweep of Whitesands Bay. I subdued Carn Llidi, the shapely hill in the background, in order to throw more weight on the centre of interest.

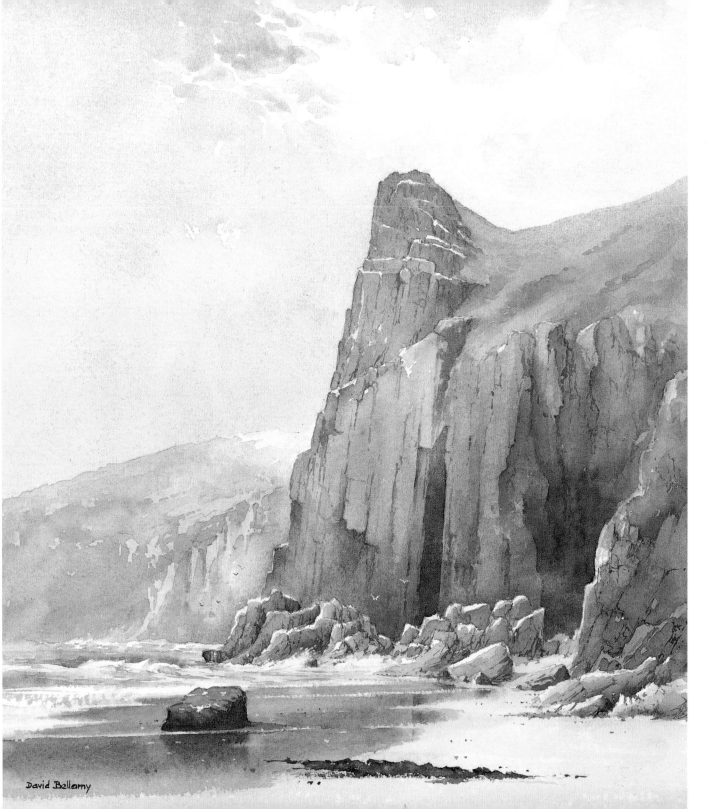

David Bellamy

◊ **Skomar, Lydstep**
watercolour
33 x 24 cm (13 x 9½ in)

Skomar Tower is one of my favourite chunks of rock, rather like an old friend. I wanted to create a sense of sunshine and power with these limestone verticals soaring skywards. I have swum, waded, climbed down and approached this inaccessible cove in a boat, and it never fails to impress me. Note the warmth in the colour of the main crag as compared to the coolness of the more distant cliffs. The flecks of white here and there put across the feeling of sunlight.

◊ **Solva, Pembrokeshire**
watercolour
22 x 29 cm (8½ x 11½ in)

Solva is another of my favourite locations for sketching. This is one of my more colourful versions, painted on Waterford 300 gsm (140 lb) Not surface paper, with an emphasis on the warmer colours. By juxtaposing the darkest dark against the white hotel the eye goes straight to it, led in also by the stream and slipway.

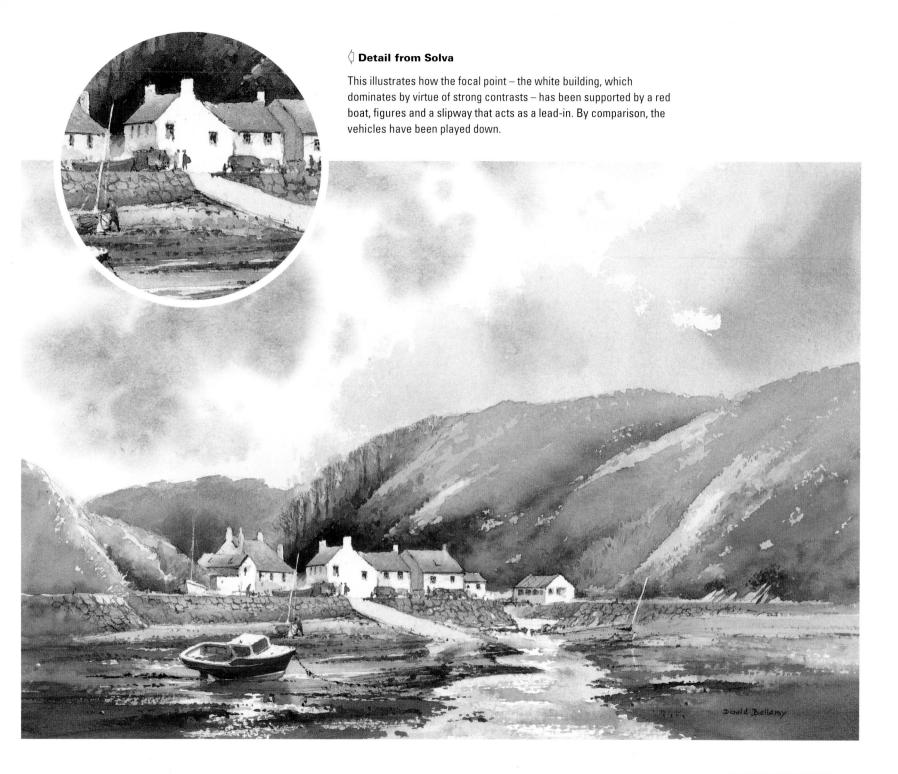

◁ Detail from Solva

This illustrates how the focal point – the white building, which dominates by virtue of strong contrasts – has been supported by a red boat, figures and a slipway that acts as a lead-in. By comparison, the vehicles have been played down.

David Bellamy

◇ **_Eda Fransden_ at sea**
watercolour
22 x 33 cm (8½ x 13 in)

This watercolour was painted on a hot-pressed surface, with the sky and sea both running in the same direction as the boat heels over to one side. Having a shaft of sunlight coming through the rigging and sails helps to emphasize the lines of the vessel as it ploughs through a rolling sea.

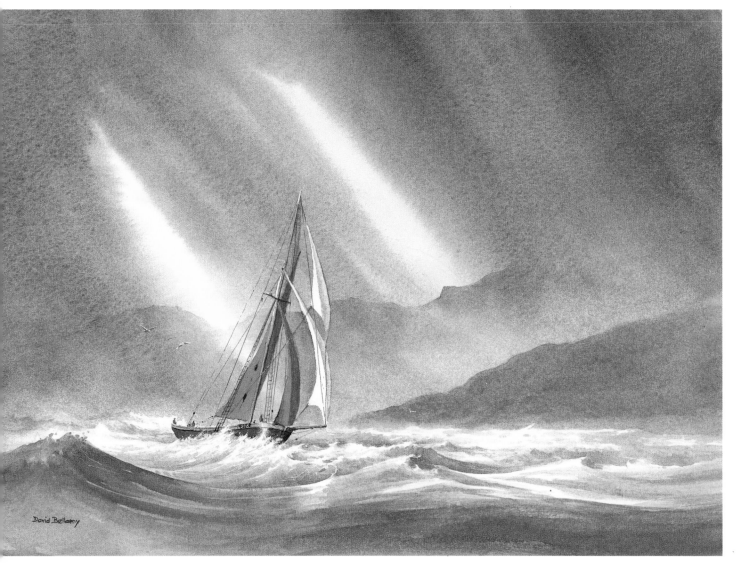

David Bellamy

◇ **Robin Hood's Bay, Yorkshire**
watercolour
23 x 32 cm (9 x 12½ in)

It was a wonderfully atmospheric afternoon when we sketched this scene, but the tide was running in fast, so Jenny and I had little time to complete our work. At times the light would shaft down from the left, with shadows across the background cliffs, to highlight the buildings and create a stunning centre of interest. The whites and reds in particular draw the eye of the viewer, and the brooding cliff top finishes it off. I painted the scene on a 300 gsm (140 lb) sheet of Not surface Waterford paper.

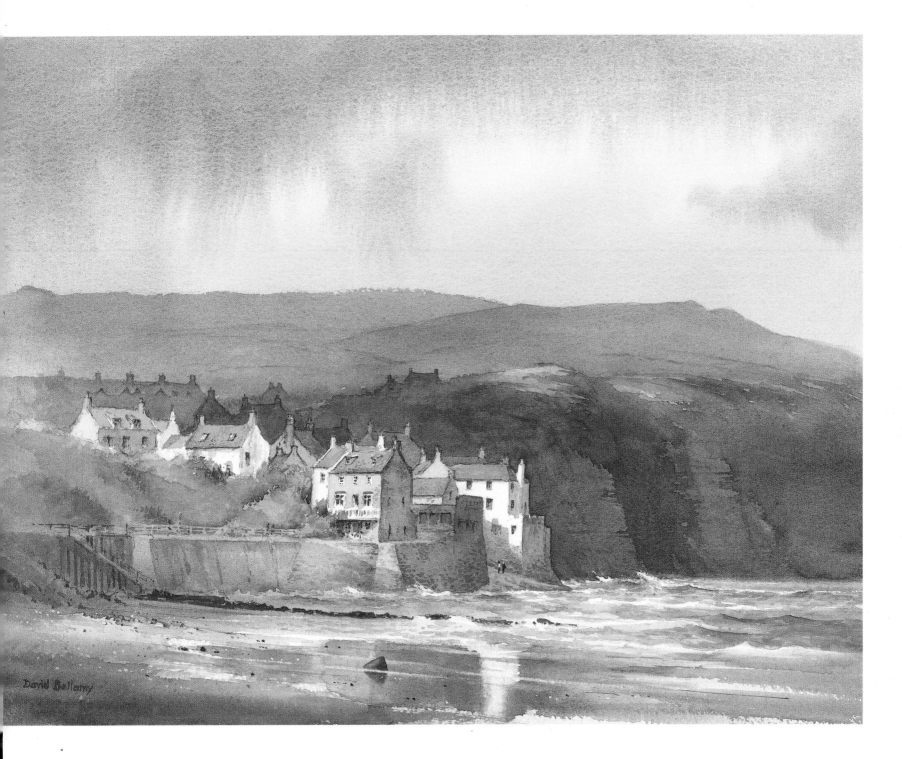

David Bellamy

INDEX

Page numbers in *italic* refer to captions